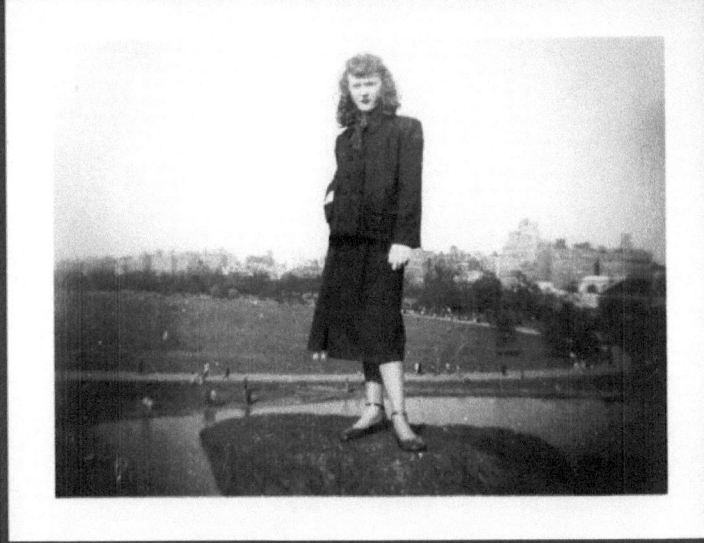

Dot

The Art of Dorothy Jean Culhane

When looking through my Mother's art and images over decades I am left with the feeling that any real art is as reflexive as breathing. I've attempted to pick out a hundred images out of a few thousand from her collection. She was a very visual person.

Dorothy Jean Culhane (née Tancibok) or Dot or Dorthé as she later signed paintings, had a great passion for creativity but led a few lives that didn't always intersect. Born on August 6th, 1931, she was a child of the depression, and her mother was prone to nervous issues and often unavailable. In my mind, this gave her a specific independence.

She was headstrong from the beginning and while a cheerleader in Hoboken High School, was scorned by a few teachers for being rebellious and speaking her mind. This is evidenced in her yearbook as she was awarded "class wit". In a picture she sneaks up behind the other class wit, who was a poet, with what looks like a hammer while smiling. It sums up her intensity for me.

She had a great love for New York City and used to tell me about going to the Metropolitan Museum to sketch with her friends when she was sixteen. After the failure of an early marriage, she lived a bohemian lifestyle on Fifth street in the East Village. It was 1960 and she told me she paid $90 dollars for a studio apartment.

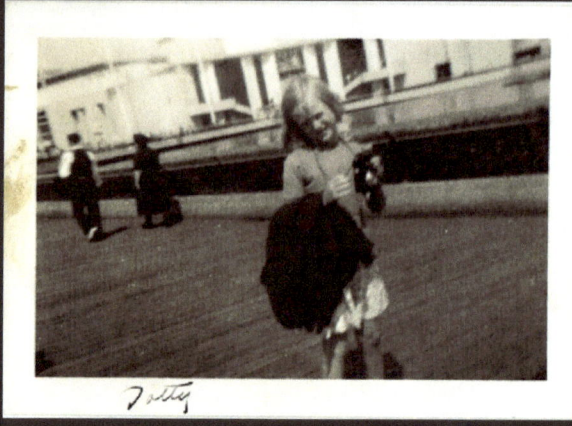

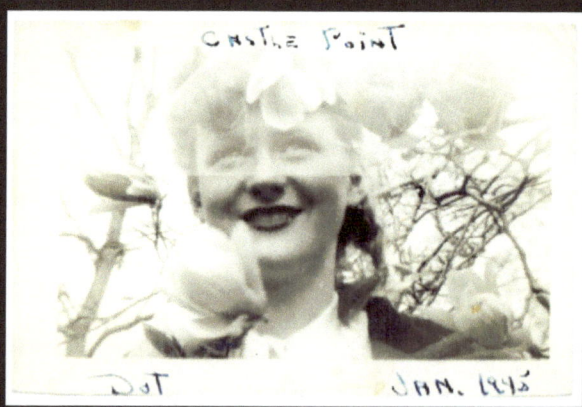

Dorothy at the 1939 World's Fair with a camera and at Castle point in Hoboken

Her father Frank came from a family of actual Eastern European Bohemians and believed all artists were bums, but of course he was extremely creative in his own right and was constantly inventing things. He worked as a longshoreman in Hoboken.

Her mother Julia was from a mysterious Viennese family, and Julia's father Max had legendarily been sent from Austria after involving himself with anarchists. He also claimed he was a Duke living under a false name on his deathbed. He spoke six languages and could sing Opera.

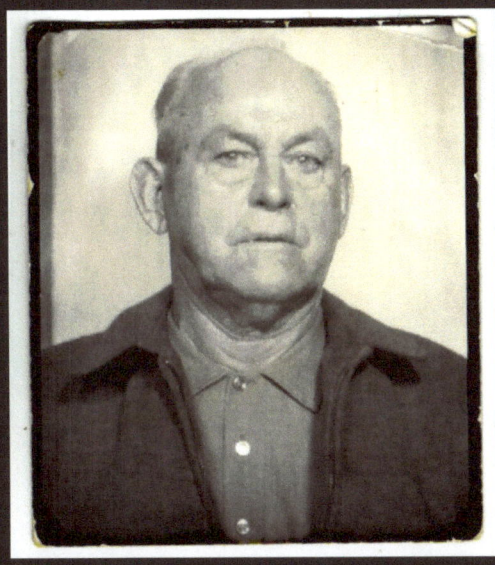

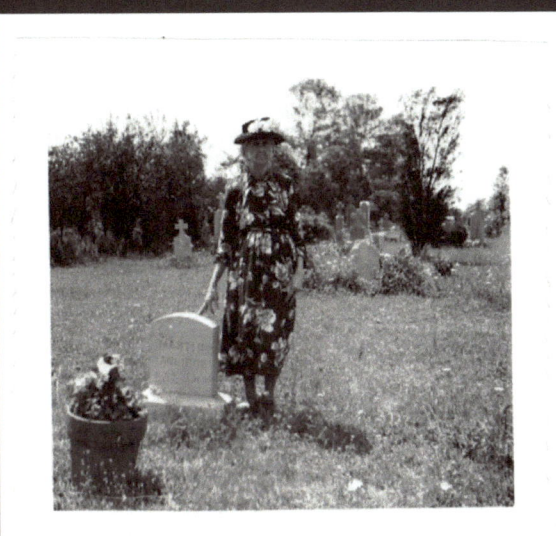

Dorothy's Father Frank Takcibok who was very Bohemian. Dorothy's Grandmother Johanna Tancibok at her husband's grave and an excerpt from her journal.

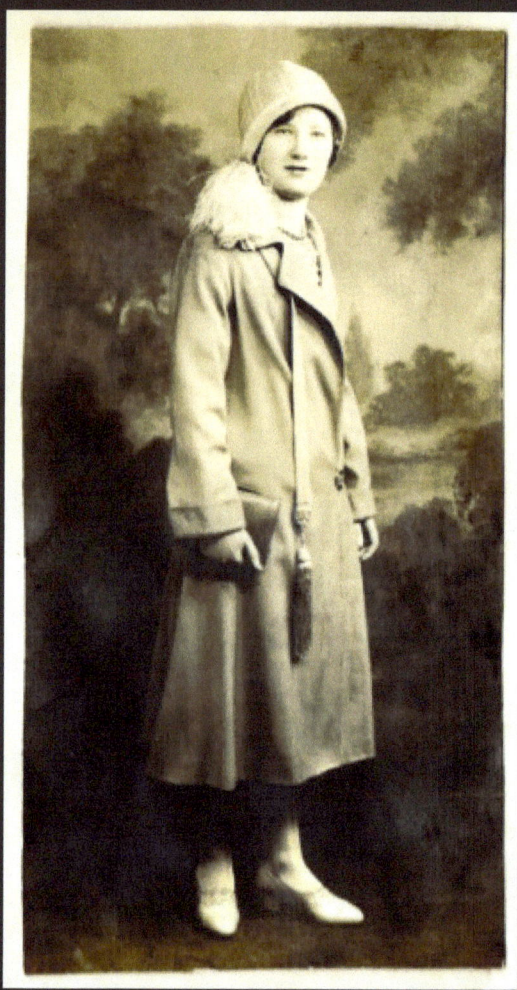 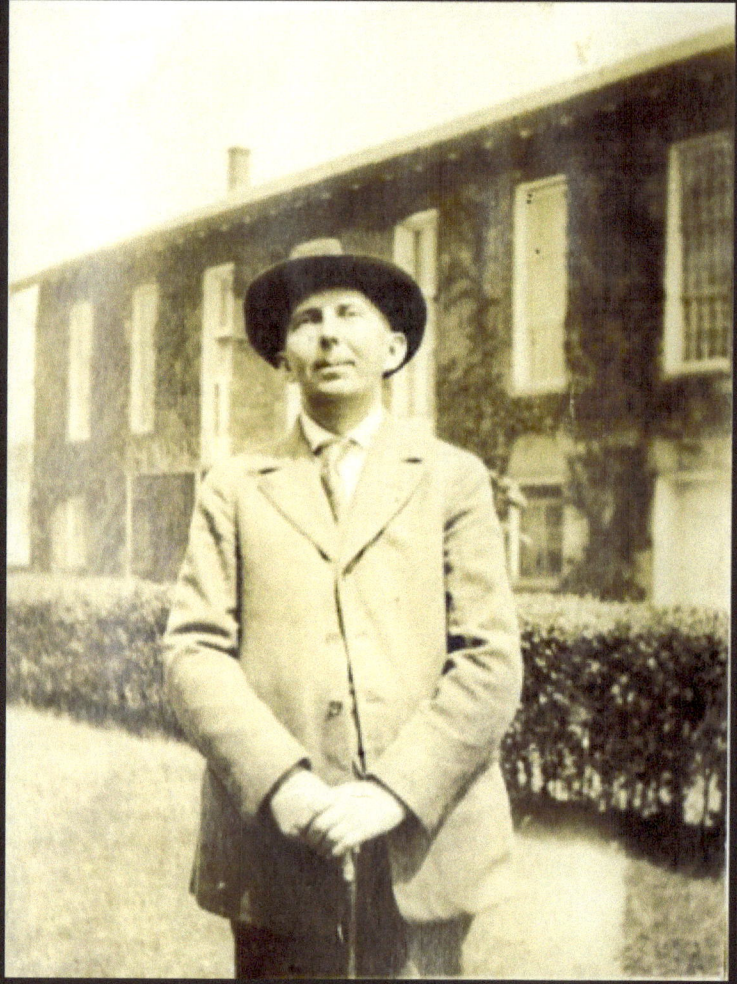

Dorothy's mother Julia as a flapper in the 1920s and her Grandfather Maximillion Stanislav Schweighoffer, an apparent Anarchist Duke.

 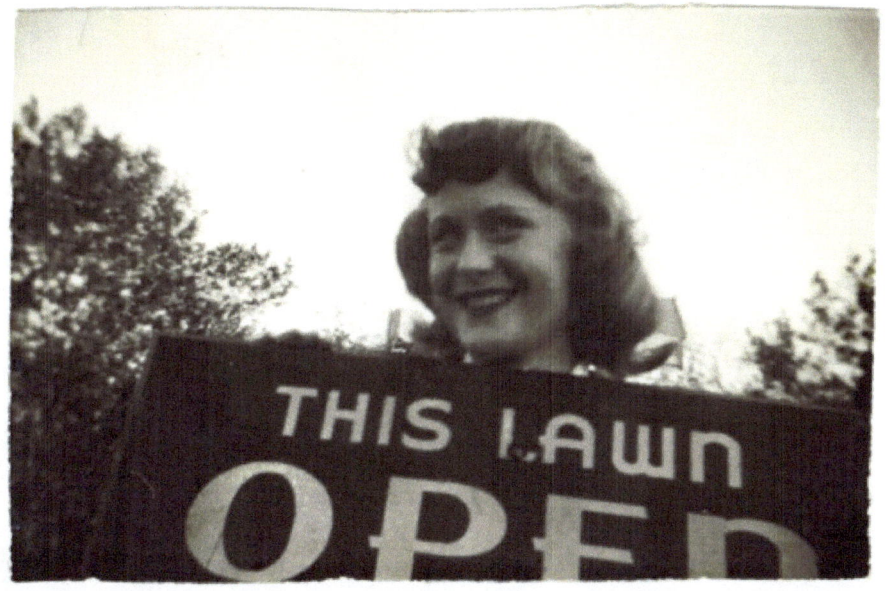

Very early pictures by Dorothy of her cat and a doll. On the back of the doll picture it's written: *Betsey the baby she was looking at the trees*. It is possible she she is stealing the sign on the lower right.

Dorothy paid her way through The New York Phoenix School of Design and later worked at Simplicity Patterns. She also designed her own clothes as her mother had done.

One of her earlier jobs in the garment center in New York was to be a fashion spy. She would go to a showroom and memorize the styles. Then she would covertly sketch out the designs in a vacant phone booth. Another short term job she had was for a well established cartoonist named Vic Herman. She may have gotten the job because she resembled the Cartoonist's characters.

In the early 1970s, as she had her own family, Dorothy moved to suburban New Jersey and pined for the city in some ways. The suburban life was to appease her father but when he passed away, this dynamic changed. As her suburban marriage ended she began a phase of significant soul searching. She lost a lot of prestige or the illusion of prestige that the suburbs brought and found herself independent again.

We used to talk about how your personal concept of ever changing New York changes behind your back when you grow older. She told me her East Village was becoming harder to find.

She gave away a lot of her art over the years to friends and created Christmas cards of her paintings. Her work was so personal that she felt uncomfortable creating art by request. This could have been due to a certain fear of criticism although it seems to me now the real art rebels create art compulsively because they need to. It makes them feel whole in the universe. They are also always visually thinking.

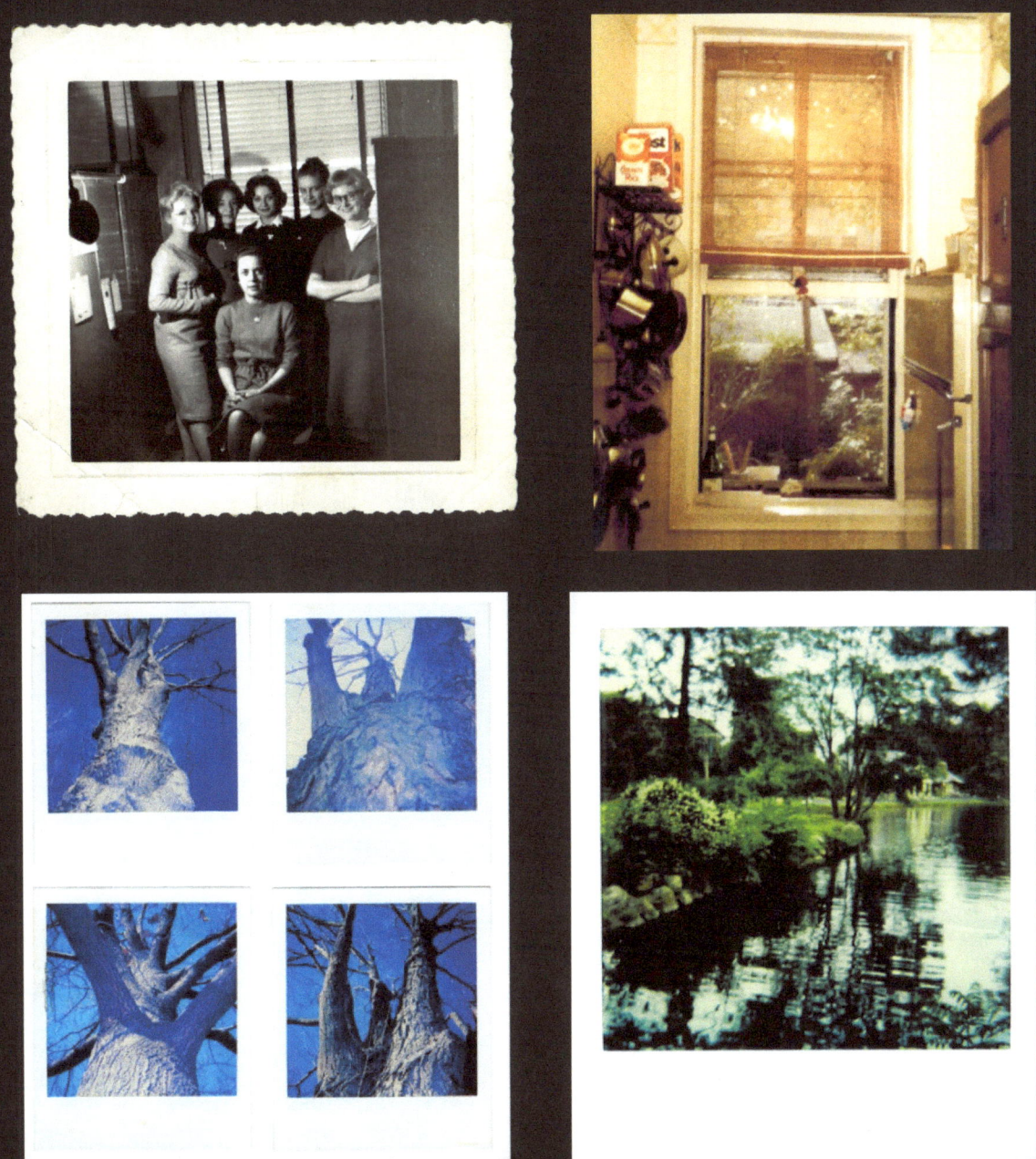

The staff of Simplicity Patterns in the early 1960s, and various studies for paintings including a Hoboken kitchen window.

Her visual drive became evident via her photographic eye for documenting and also appeared in many reels of super 8 film. There seems to be a trickster quality in many photos she took and a curious focus on disguises.

Her later travels took her to Paris, Spain and England recording journals and developing ideas for artwork. She exhibited paintings at the North Hudson Art League and at the North Bergen Art League. She received Honorable Mention for exhibits at the Livingston Art Center and won awards at the New Jersey Center for Visual Arts in Summit, New Jersey.

She loved romantic and Bohemian music that inspired her to paint and draw.

Before she passed away and was in home hospice surrounded by walls full of all her paintings, the constant flow of nurses became more at ease when they learned that all the art was created by her. The paintings had a certain positive affect even in such negative circumstances.

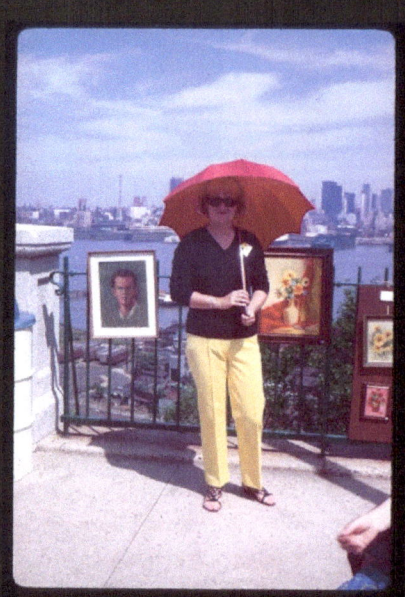

Ironically, some of her paintings ended up in the same Hoboken house where she was a nanny in her teens. They are practically in the same room, although the family changed a long time ago.

An odd painting included here reflects the night she passed two days before Thanksgiving 2015. It is the only painting like this. There was a full moon that night, the trees bare, and the house looks exactly like a friend's place.

Dorothy in North Bergen NJ with paintings

I've concluded through her work, that the best art is automatic and compulsive by nature. It is unnatural when the artist is *not* creating. That true passion and energy is not posturing, but honest.

J.F. Culhane (2017)

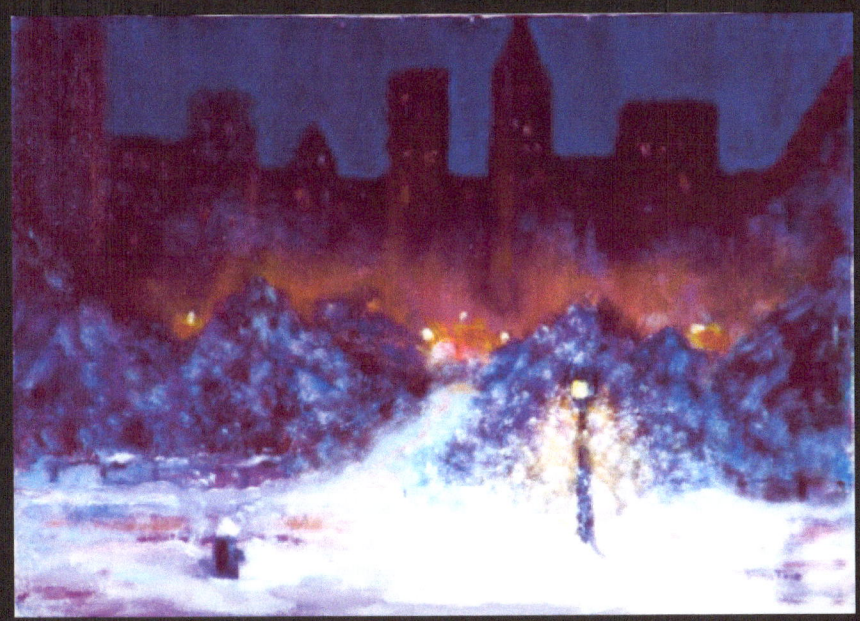
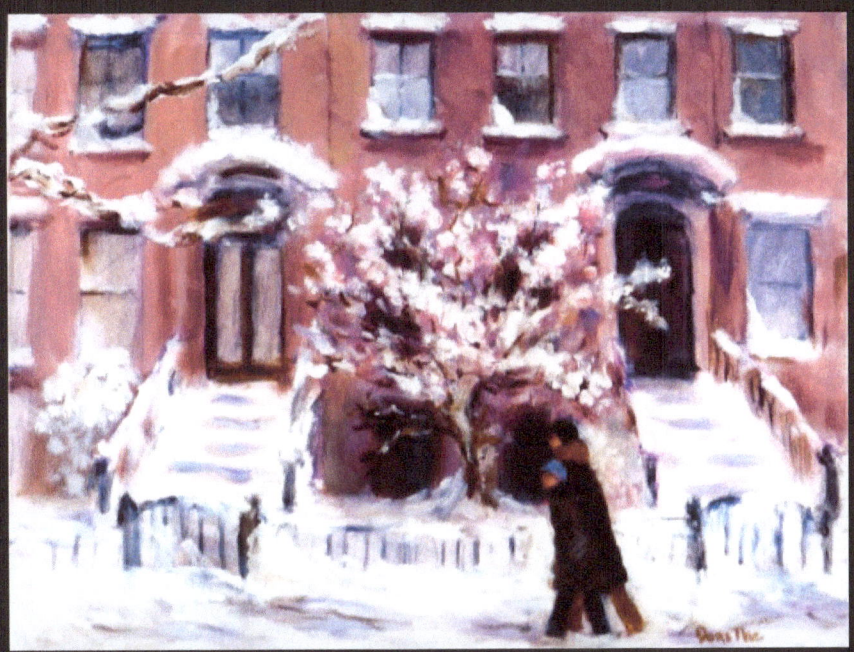

Paintings of NYC, and Brooklyn in the snow

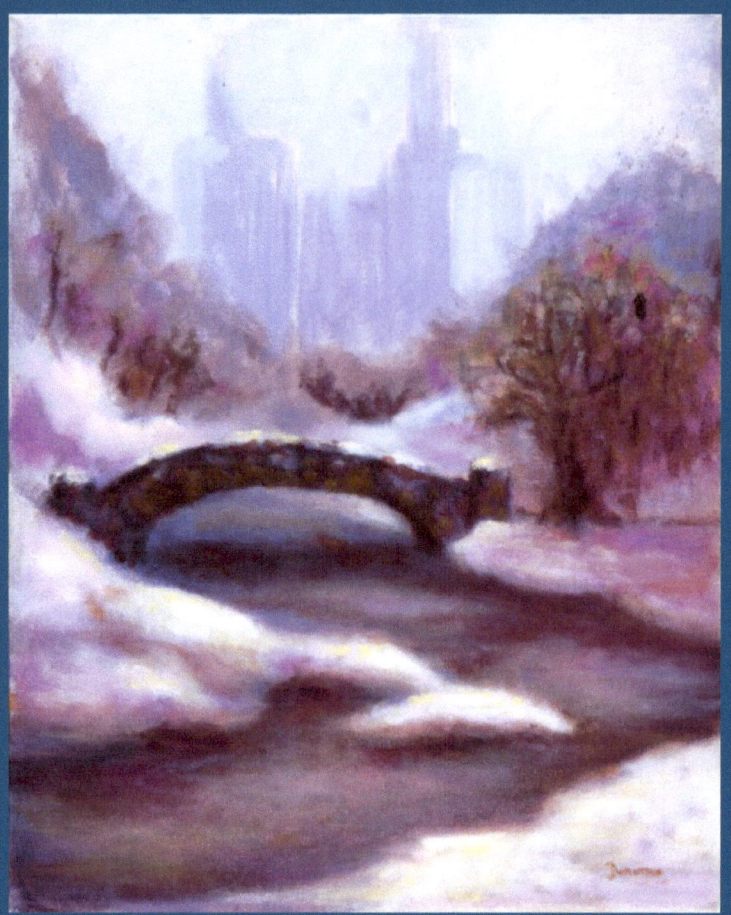
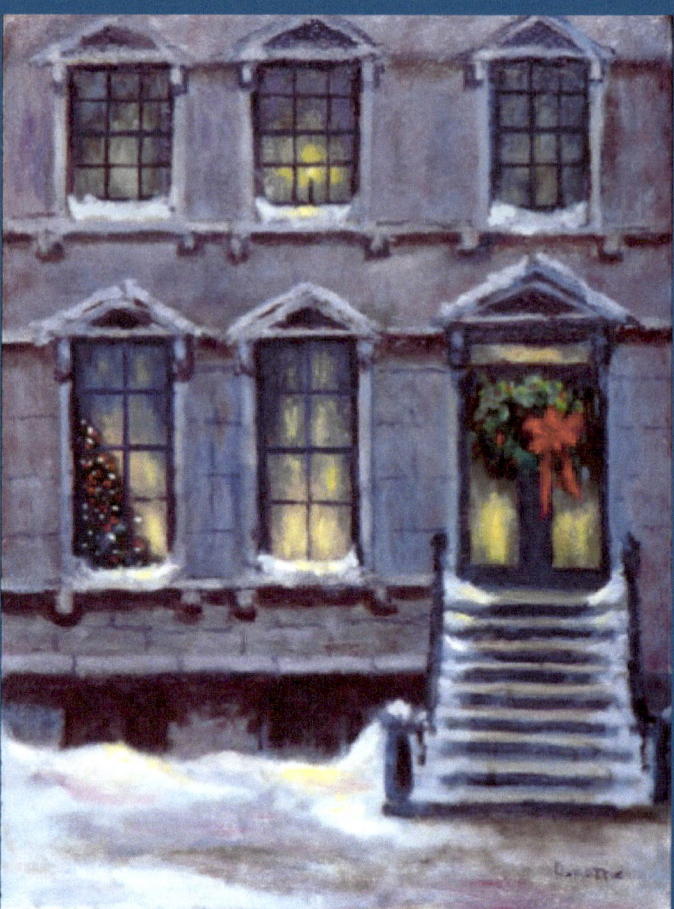

Central Park and Garden Street in Hoboken

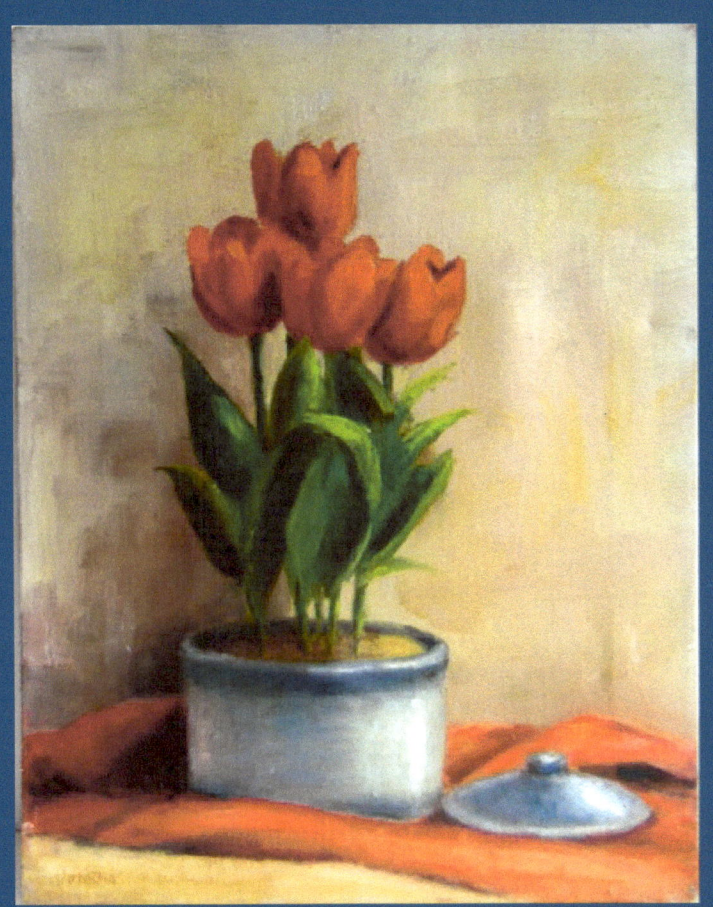 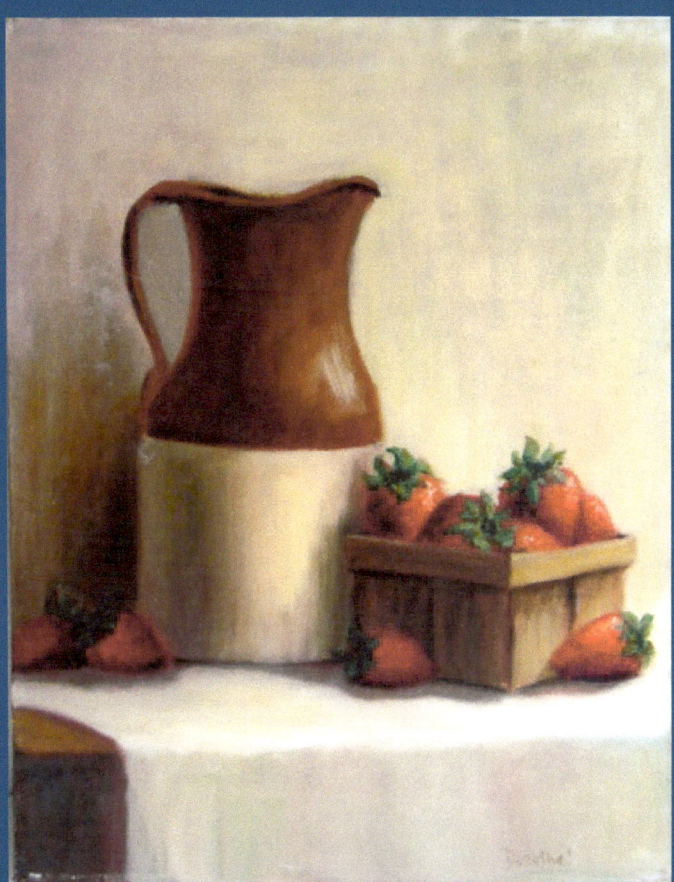

Various still lives

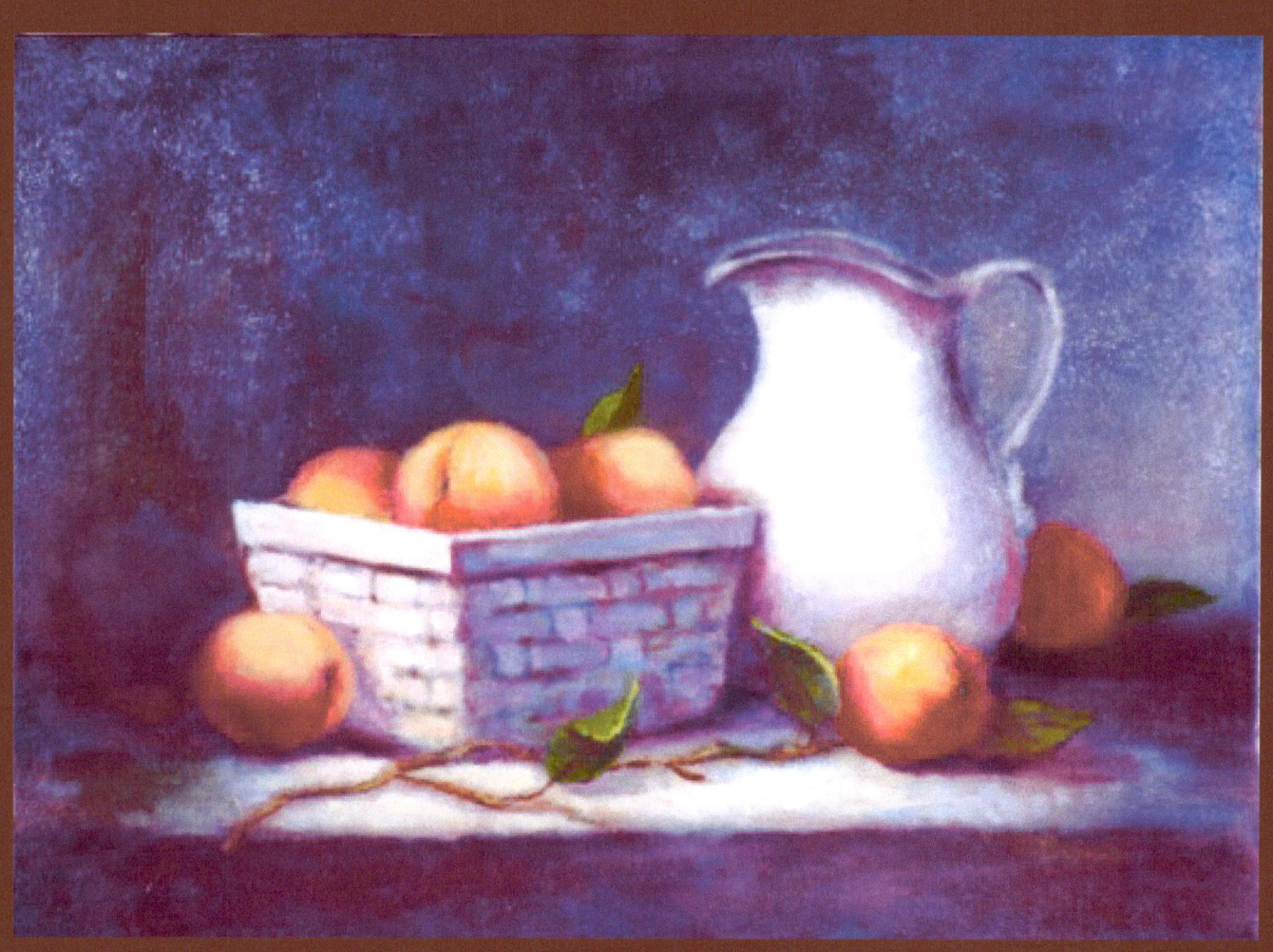

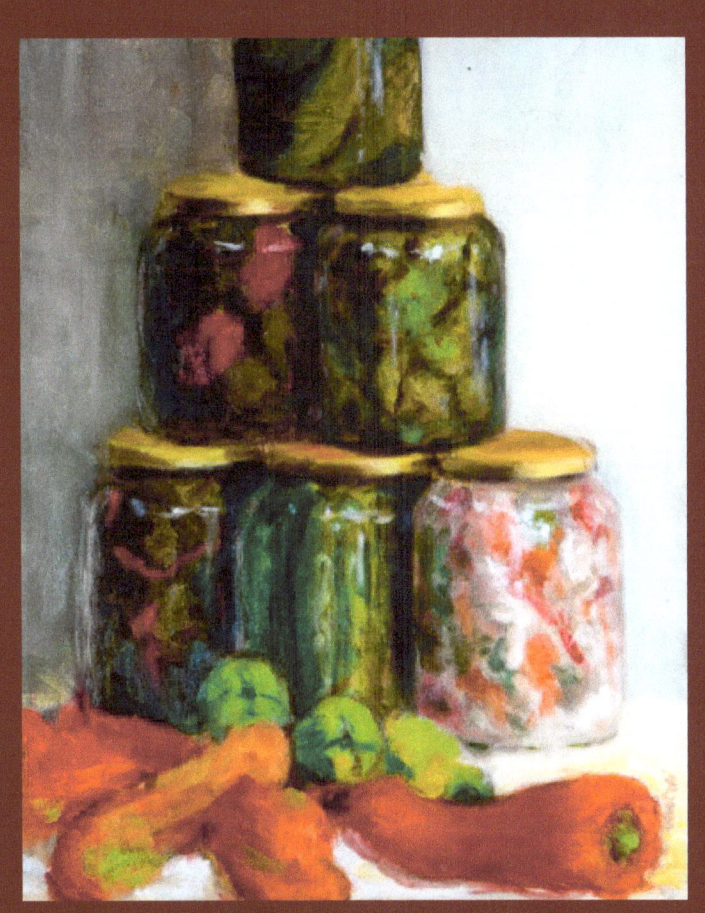
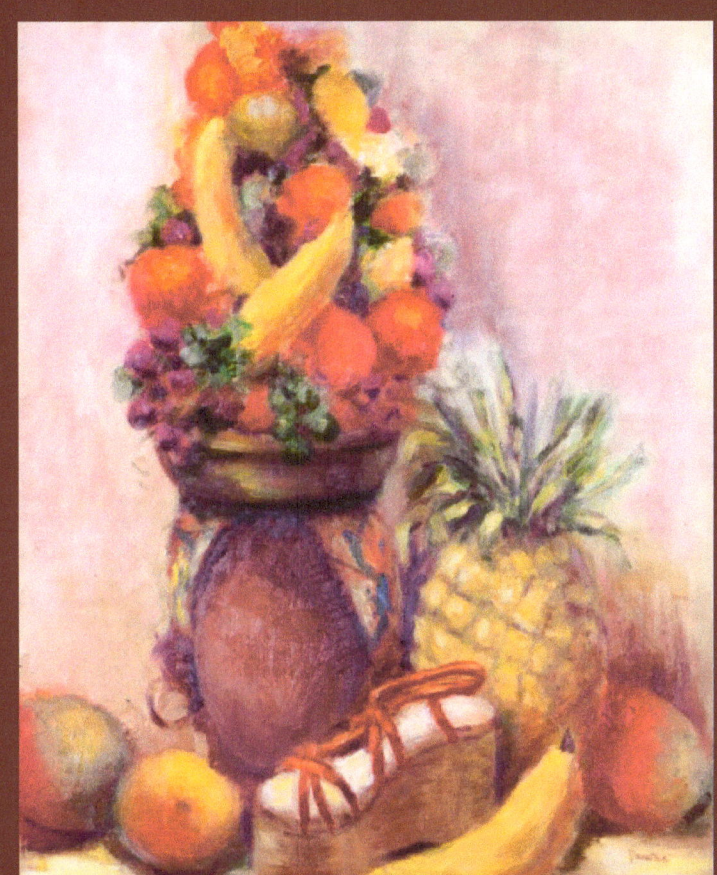

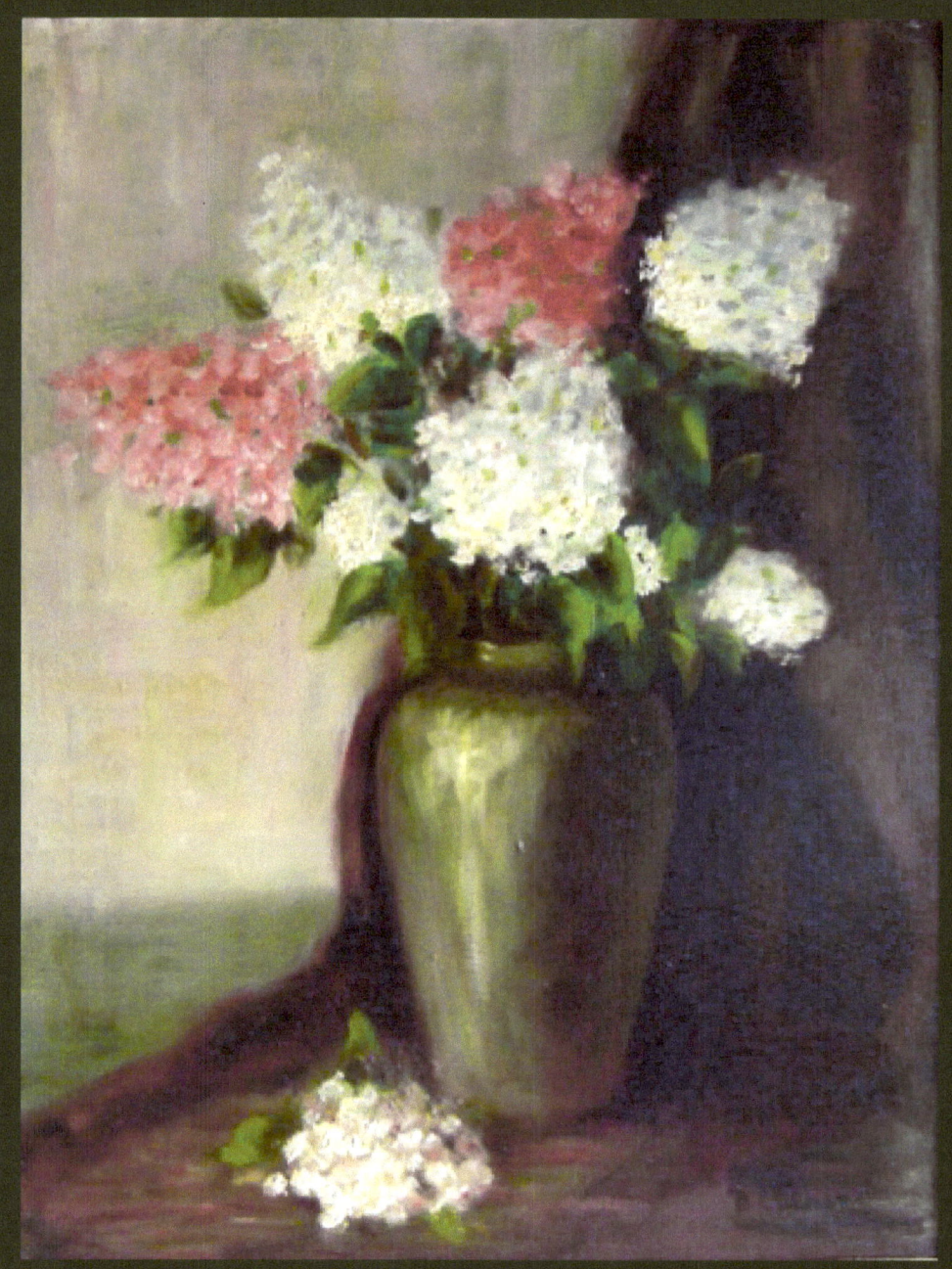

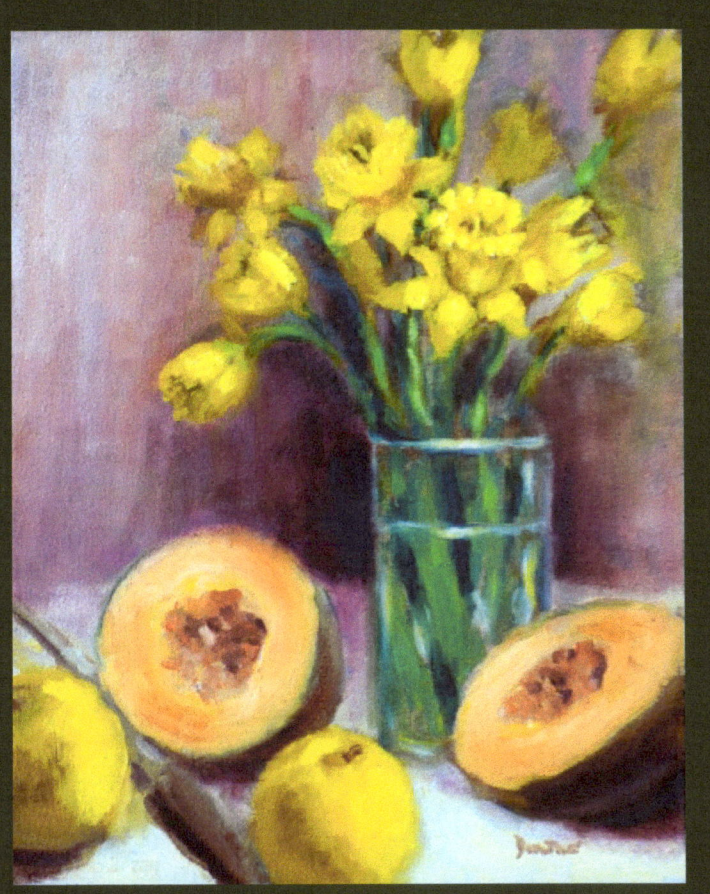
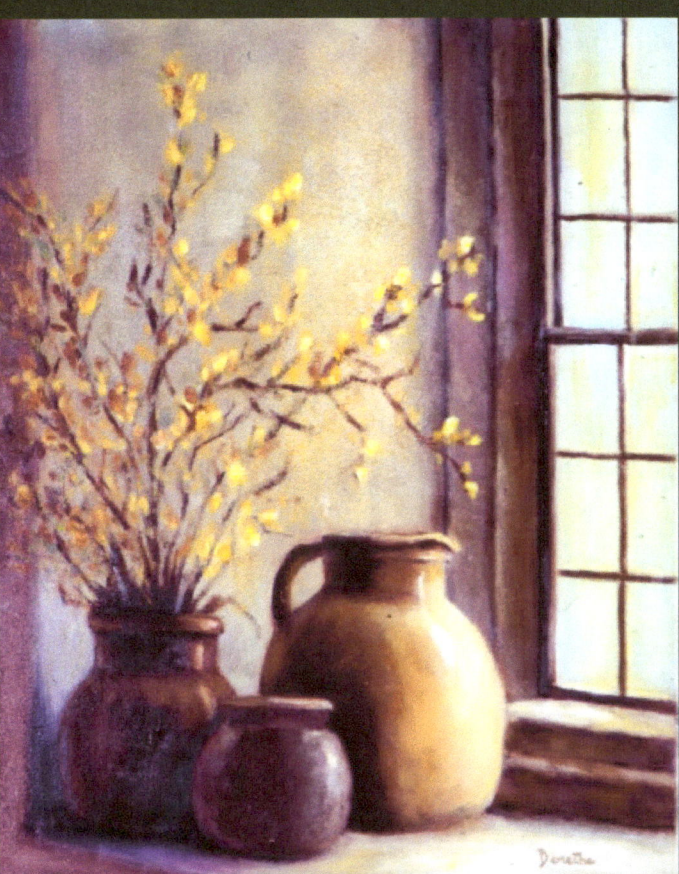

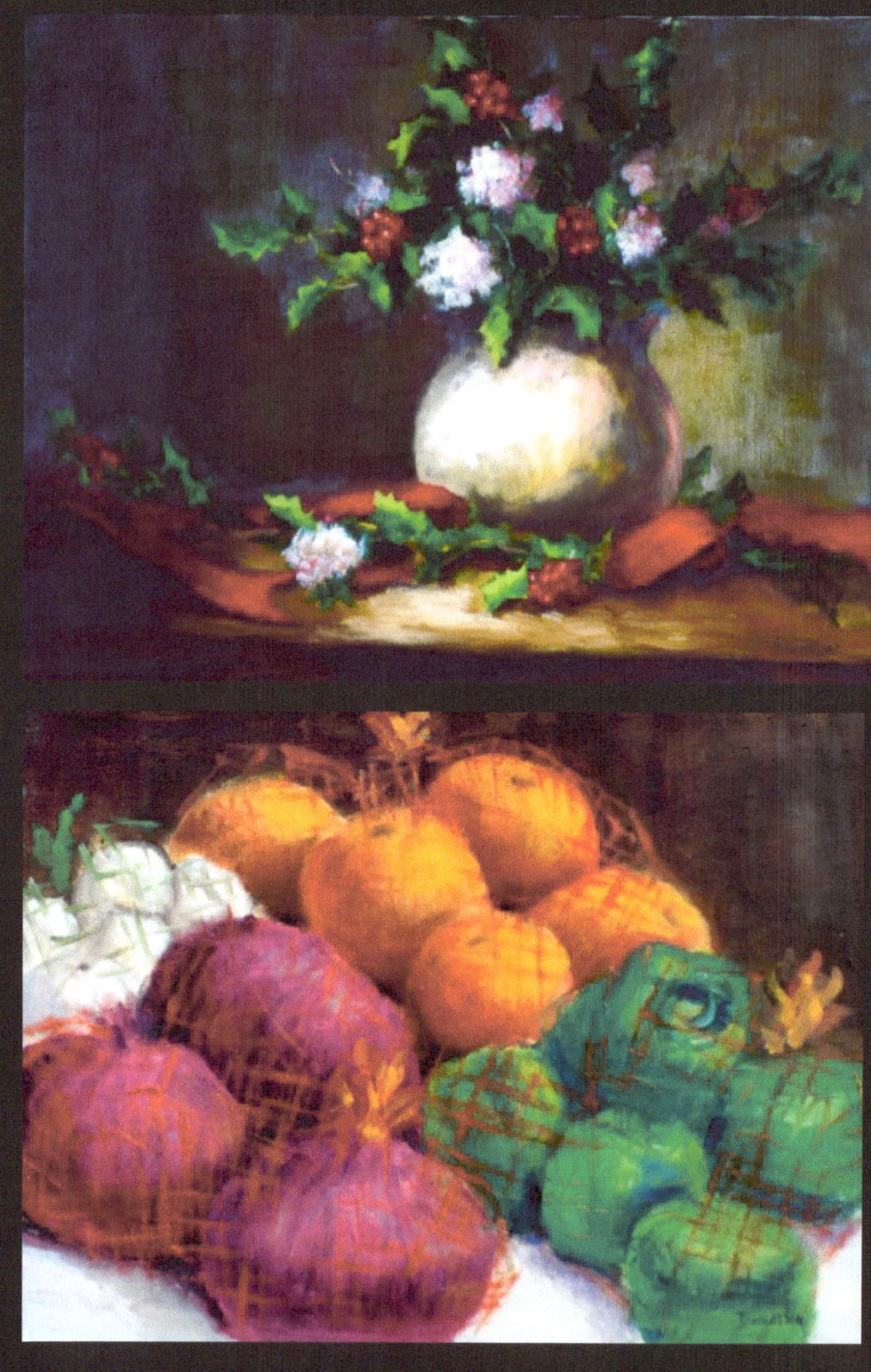

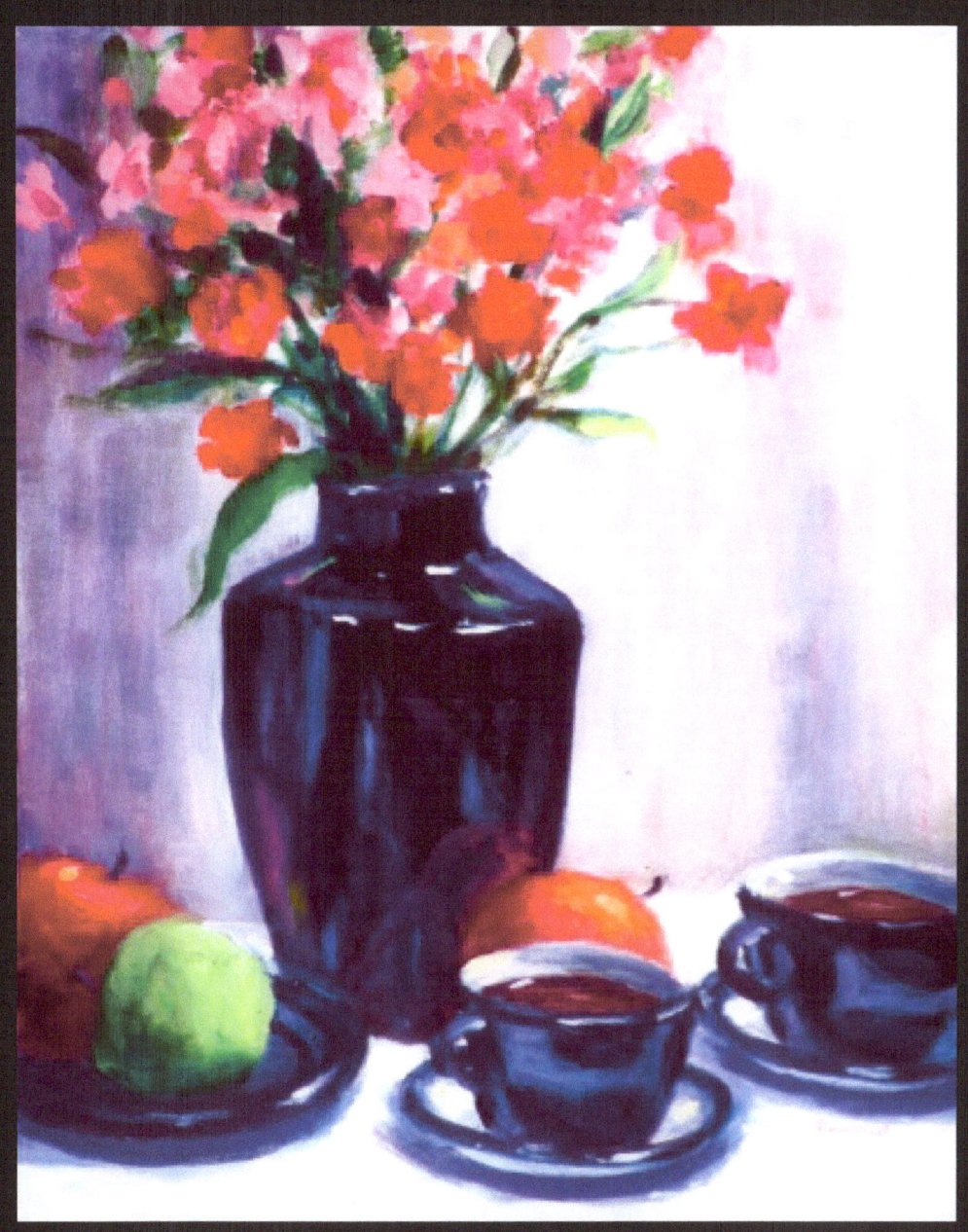

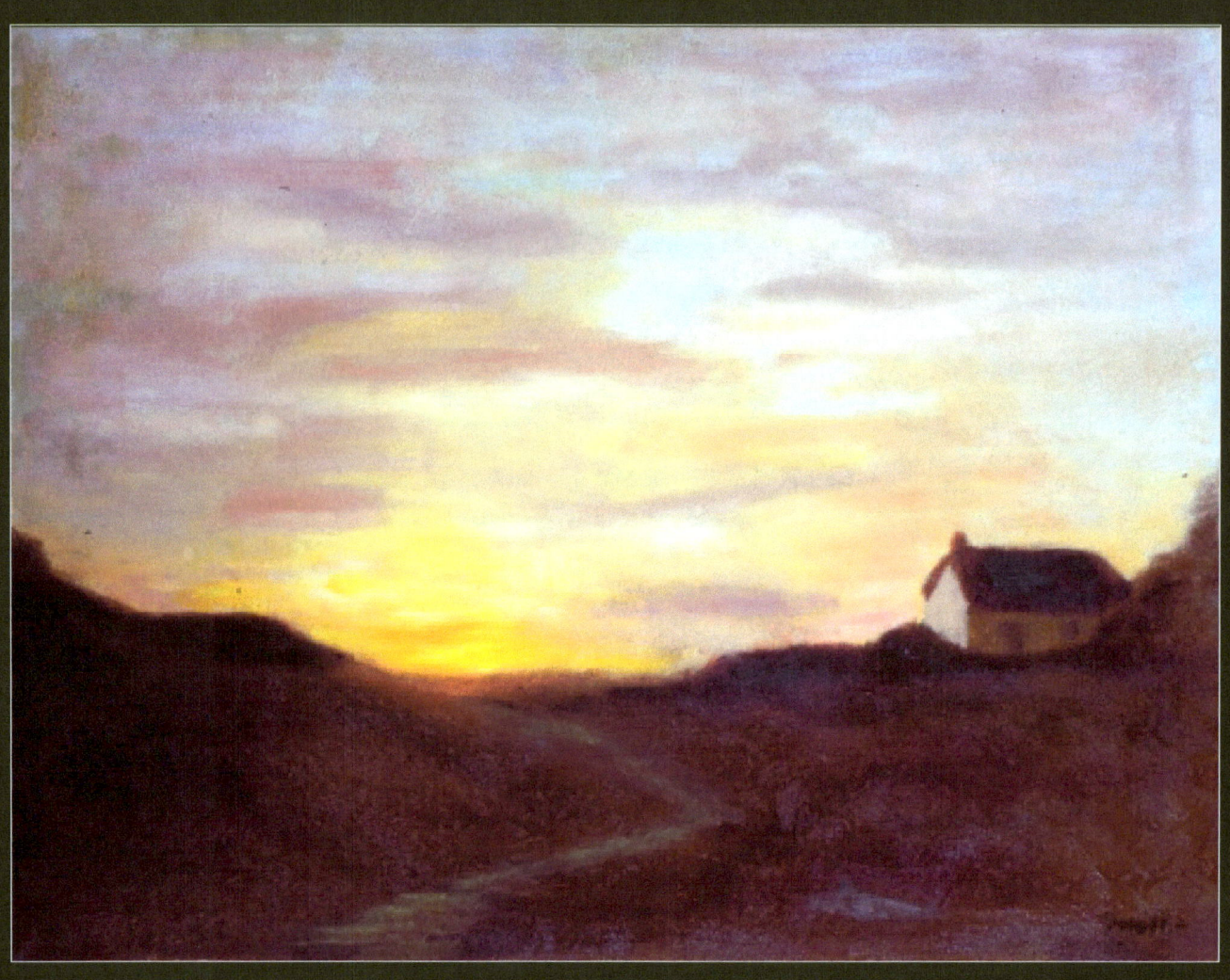

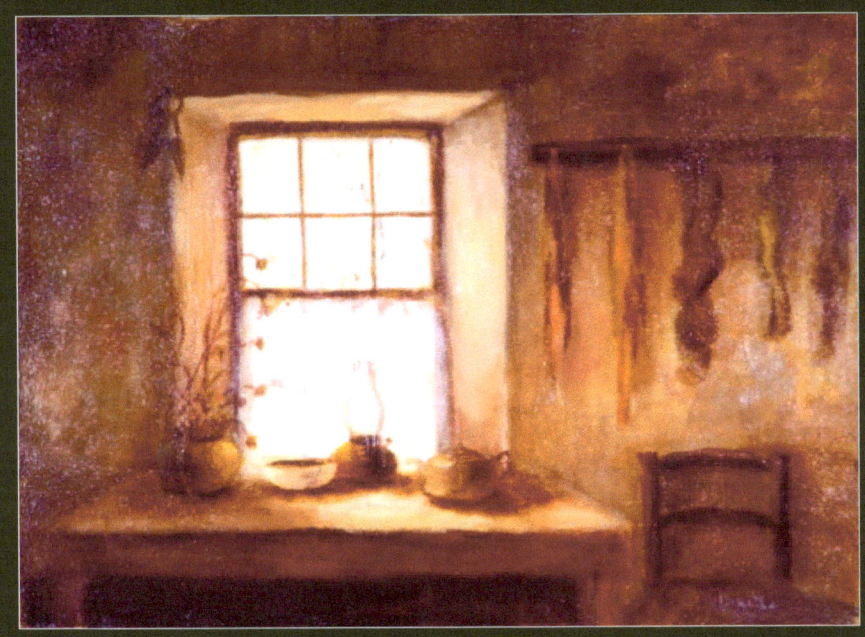

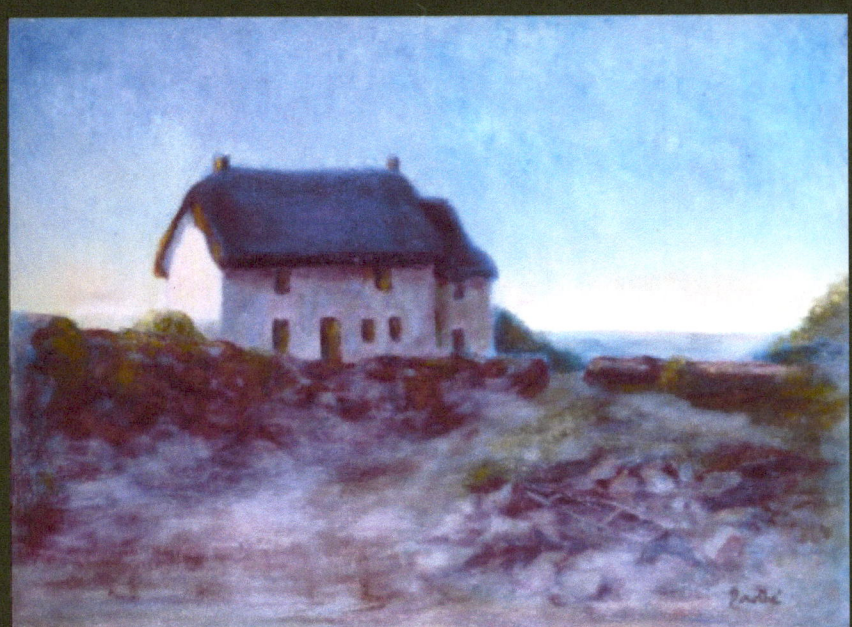

Cornwall, England

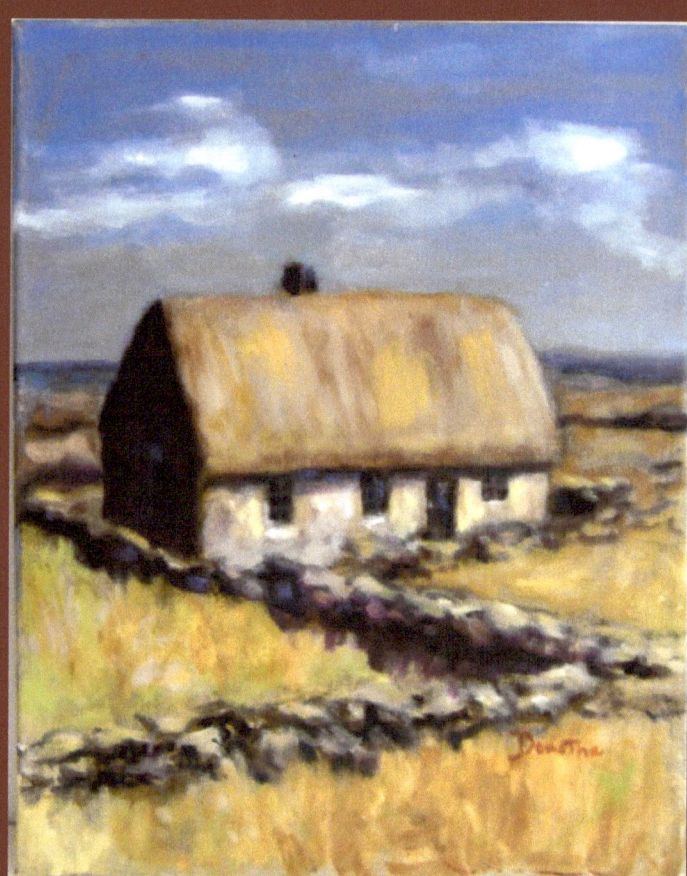
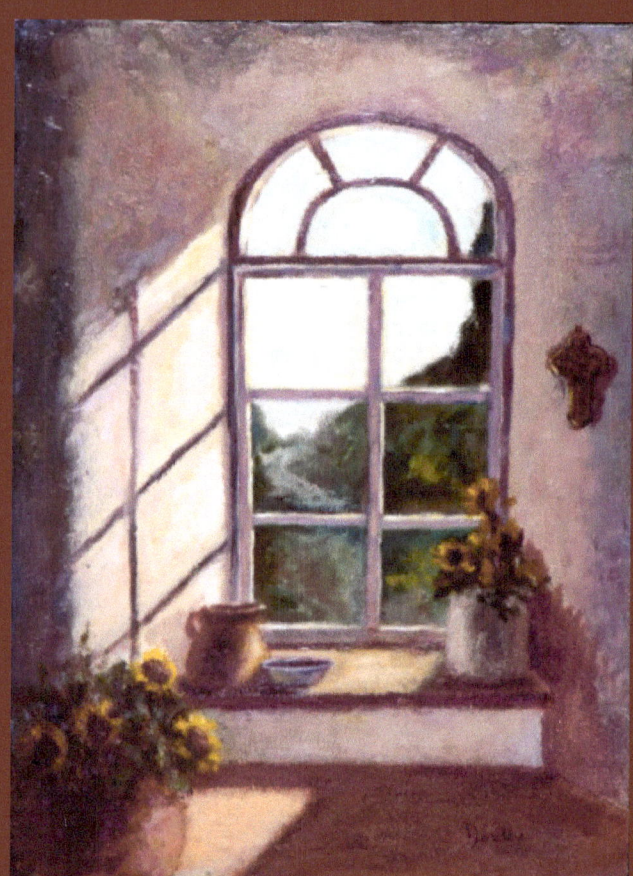

Cronwall, England

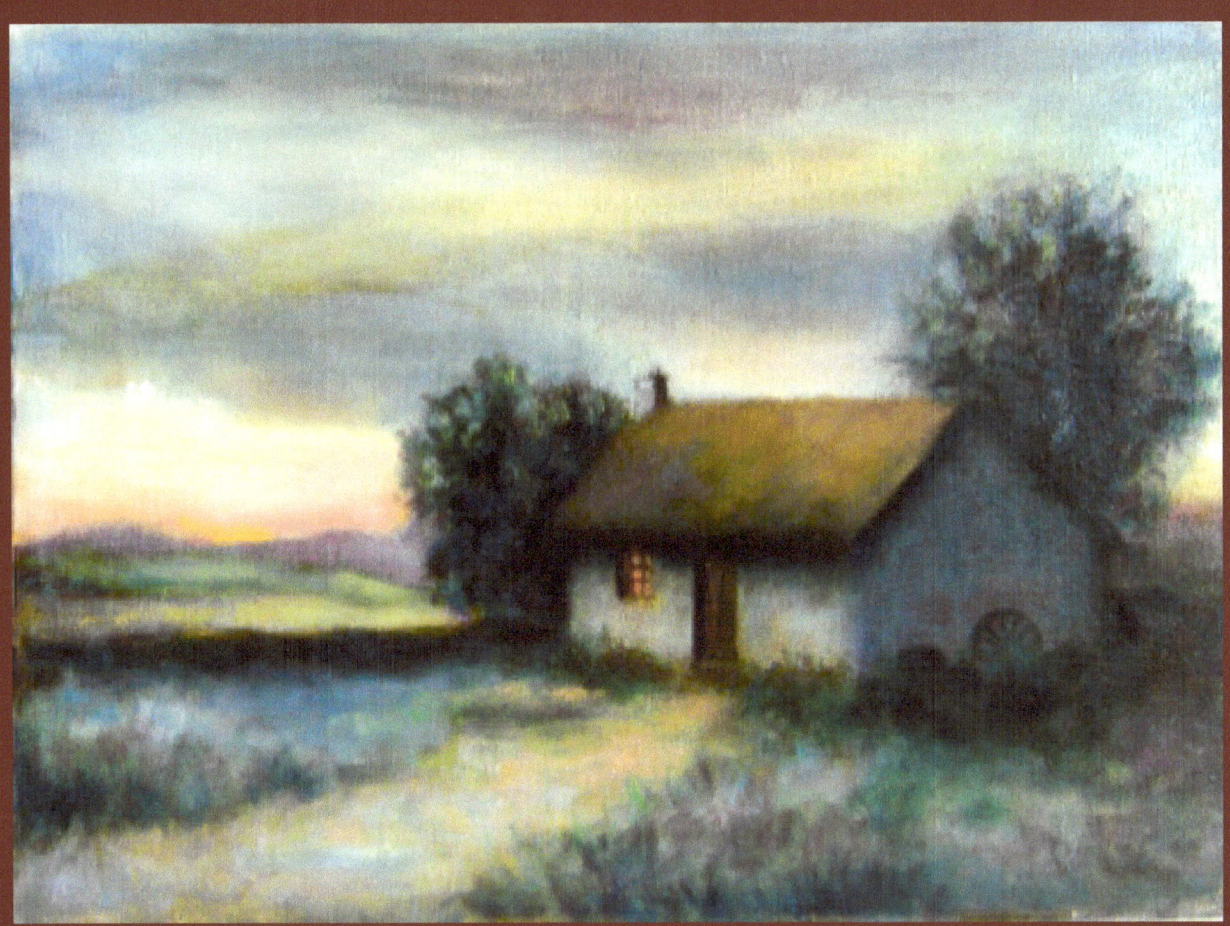

England

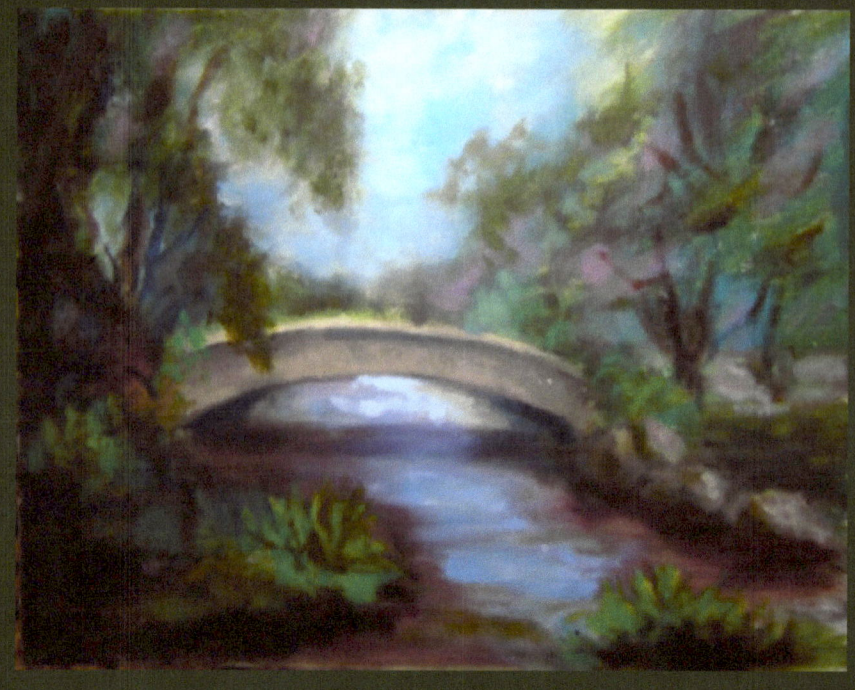
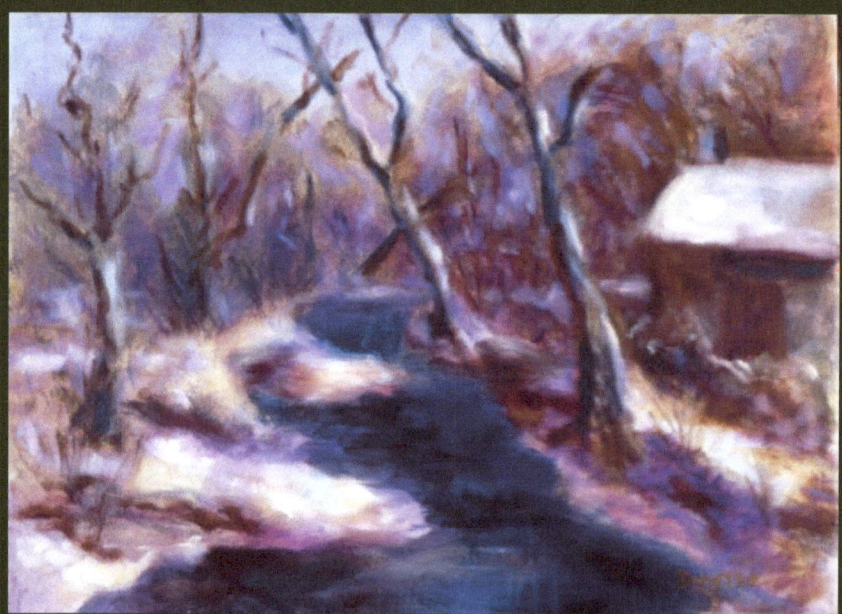

Landscapes from imagination

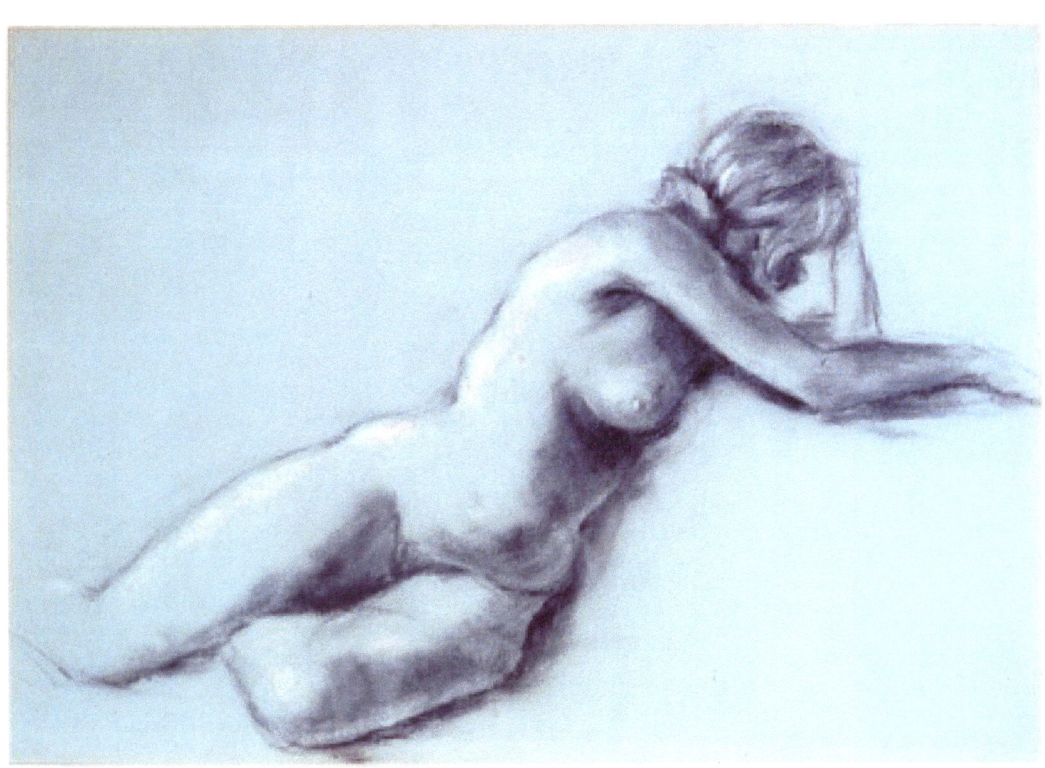

Charcoal figure

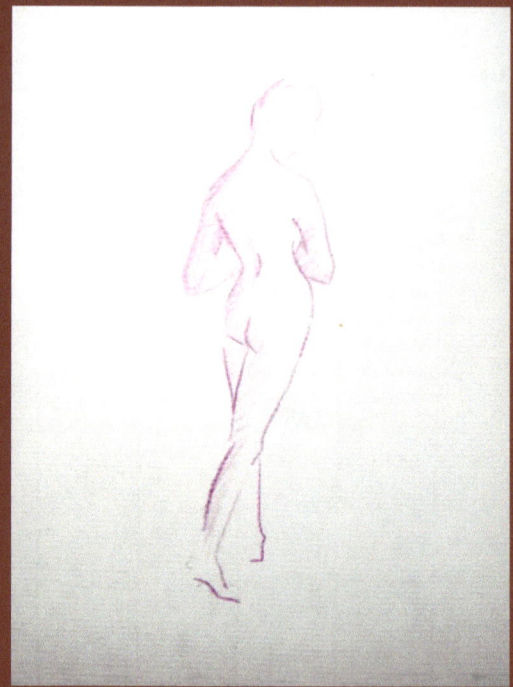
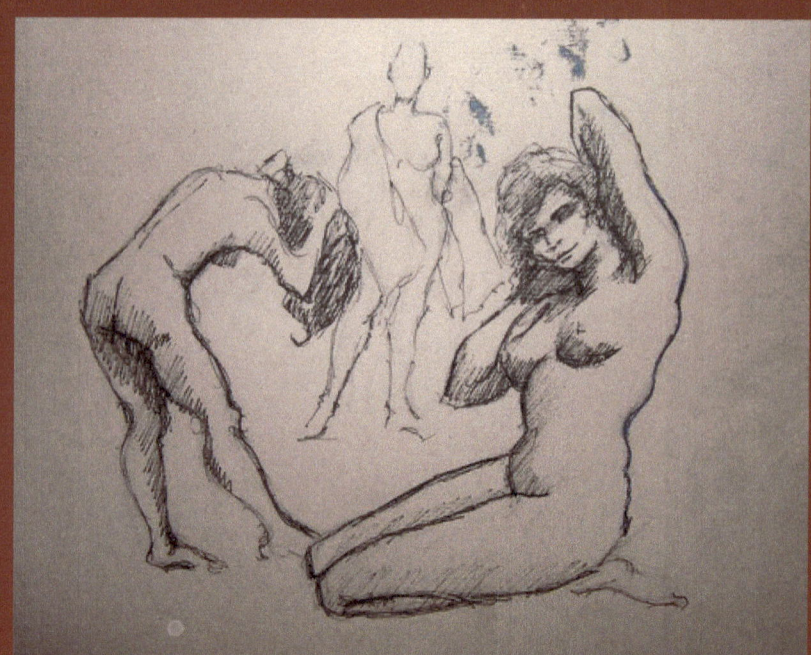
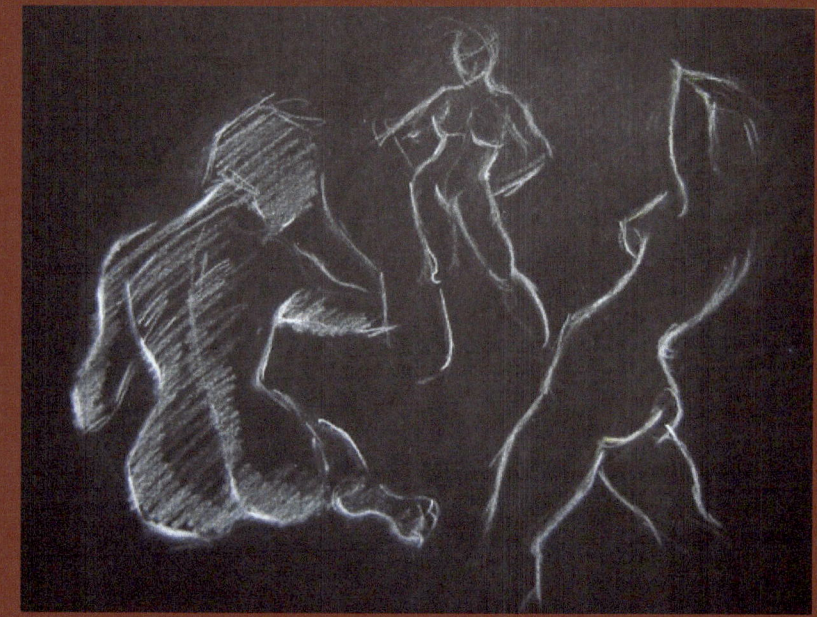

Various figure studies

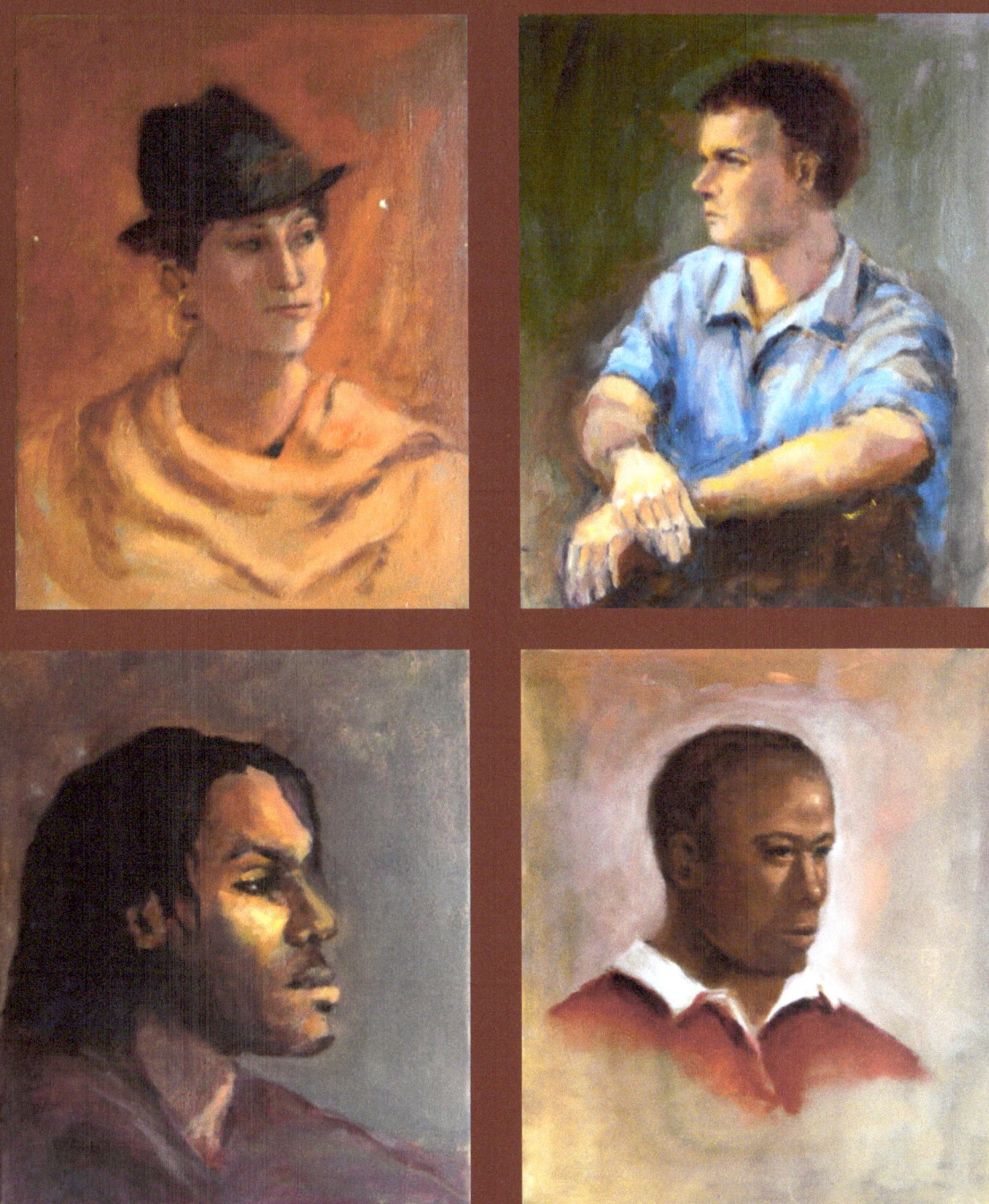

Portrait studies

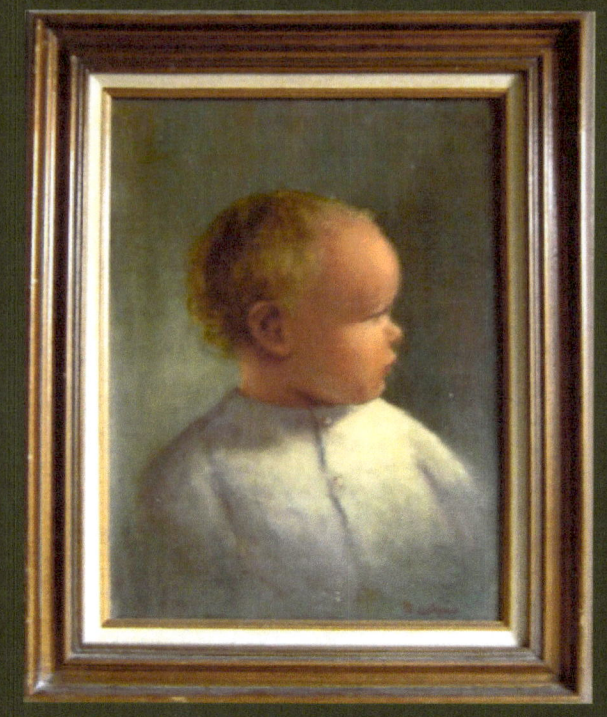
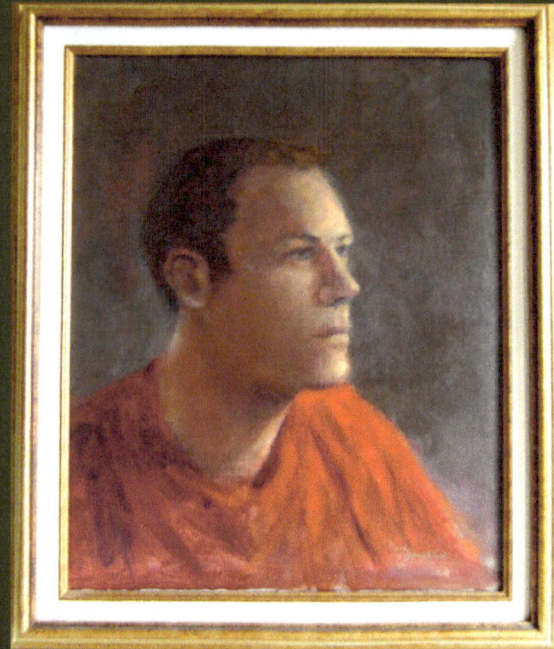
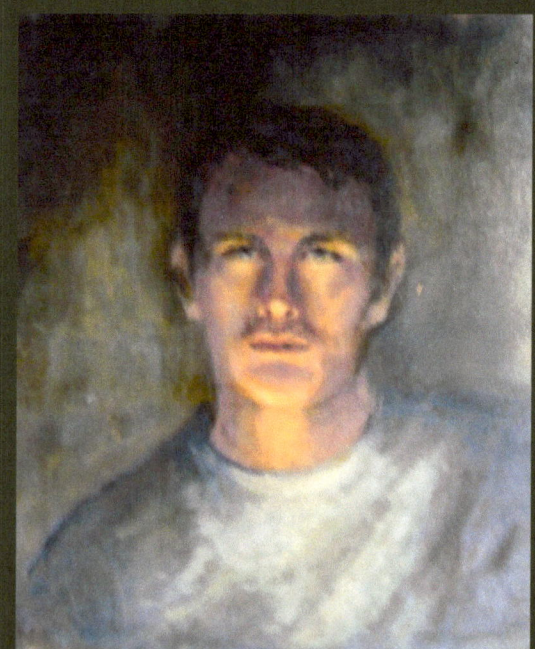

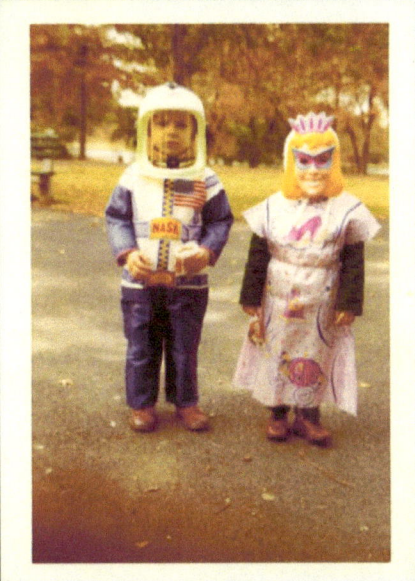
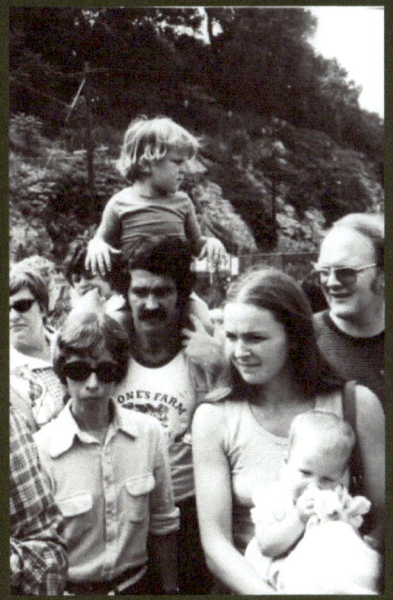

Portraits

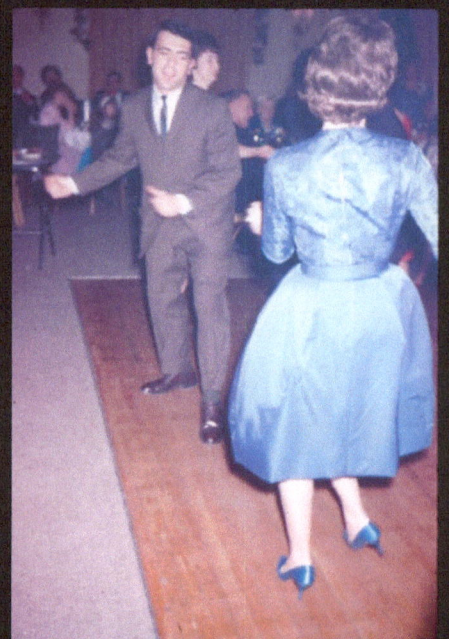
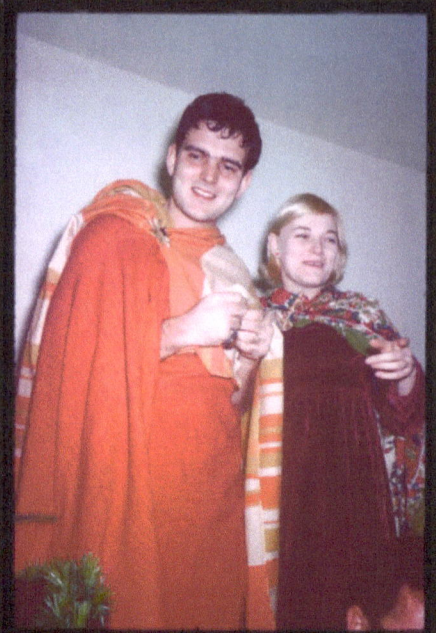
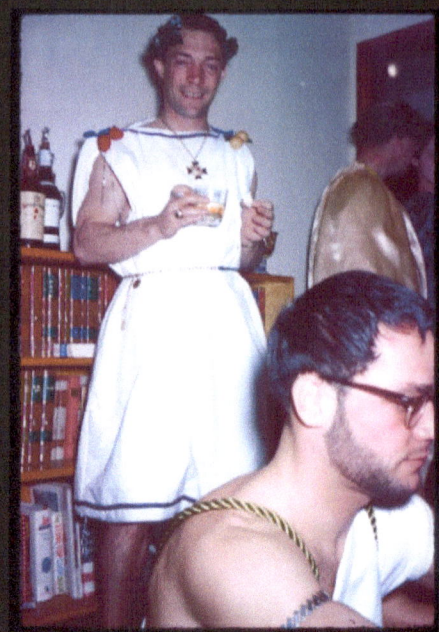
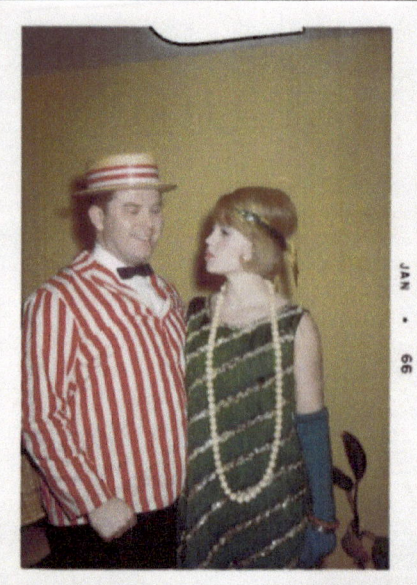

Parties in the 1960s

Dorothy's father Frank in Madison New Jersey

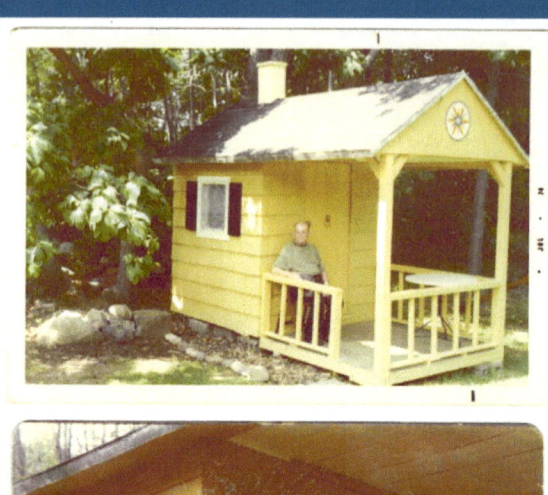

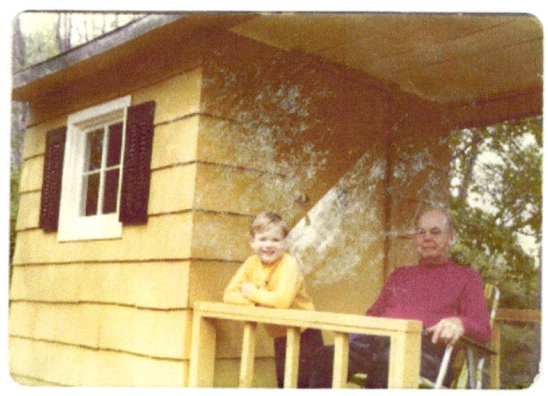

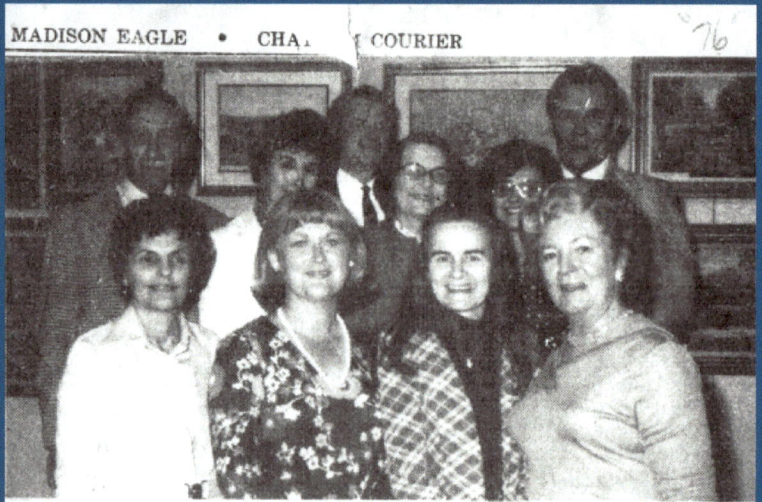

MADISON EAGLE • CHA[...] COURIER

ART EXHIBIT - A large group of friends attended the preview of the exhibit of 61 Oil Paintings by adult pupils of Kathryn Oxford Lachner on Sunday, Apr. 25, in Madison Public Library's Chase Room. Background music was provided by Miss Sally German, pianist. The exhibit is open daily through May 7 from 3 to 5 p.m. Pictured are (front row, l. to r.) Mrs. Newton Terzian, scheduling chairman; Mrs. J. Culhane, co-chairman social committee; Mrs. Reezin Swilley, exhibit committee; Mrs. Anthony Christian, social chairman; (in back) Mr. and Mrs. Charles Ciancia, Dr. and Mrs. Frederick Shippey, exhibit committee members; Mrs. and Mr. Breck Combs, exhibit chairmen.

29 Woodland Road, Madison New Jersey 1970s

 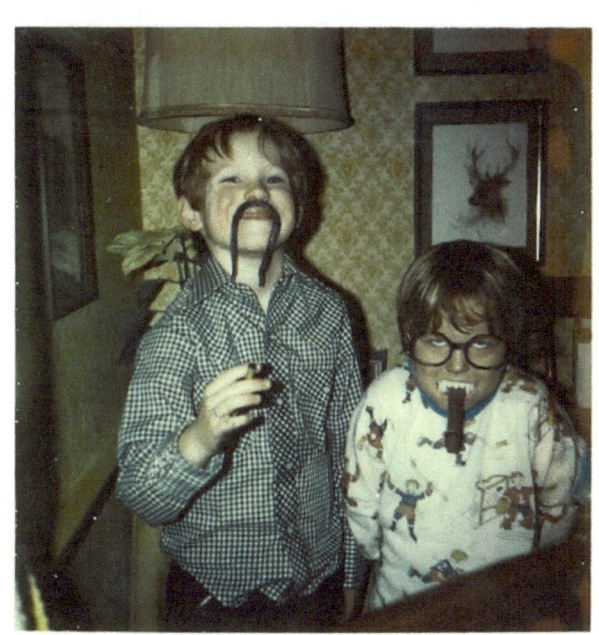

Portraits in Madison, New Jersey 1970s.

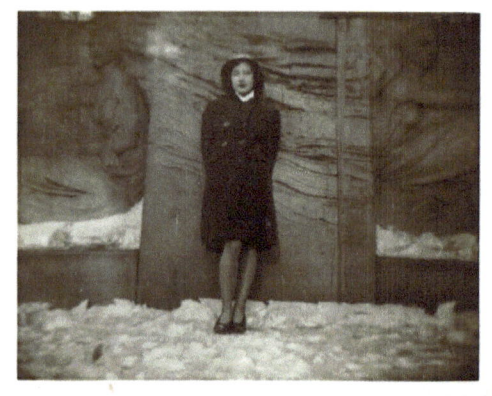

Some portraits from Hoboken NJ

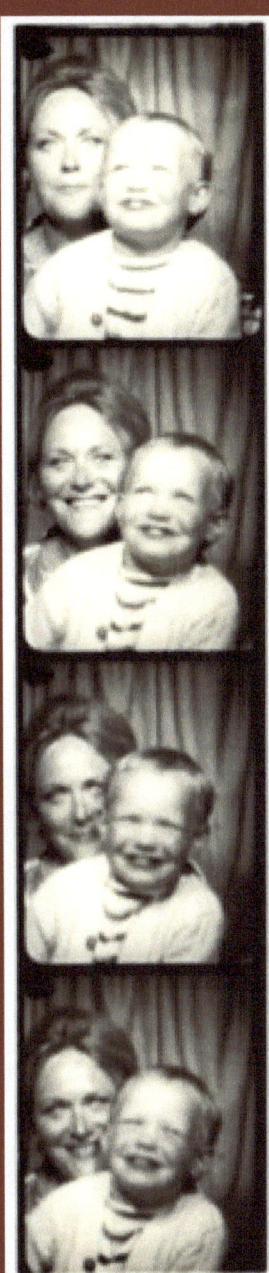

Madison backyard and the World Trade Center, 1970s.

Various pictures and slides

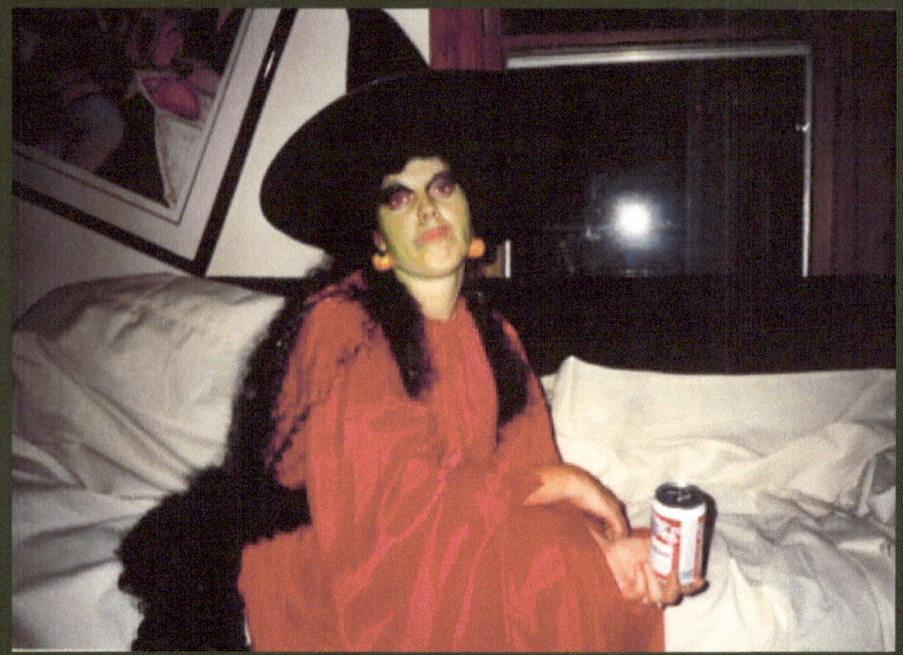
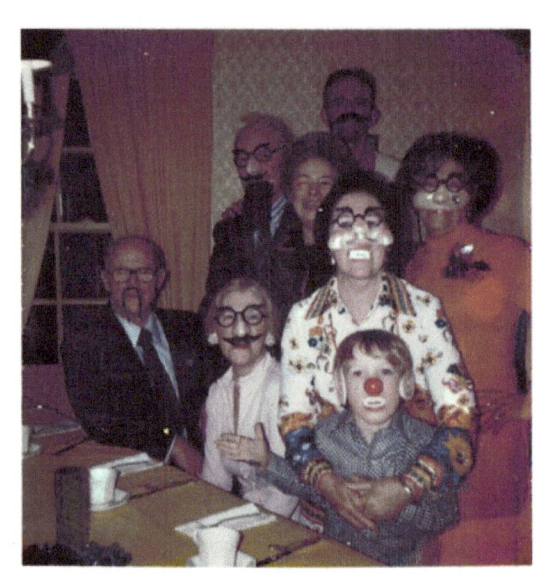

People in costumes including Dorothy herself on lower right in magenta. New Jersey

Travel photos and studies in Spain and France

More travel studies in the Caribbean, Spain and England

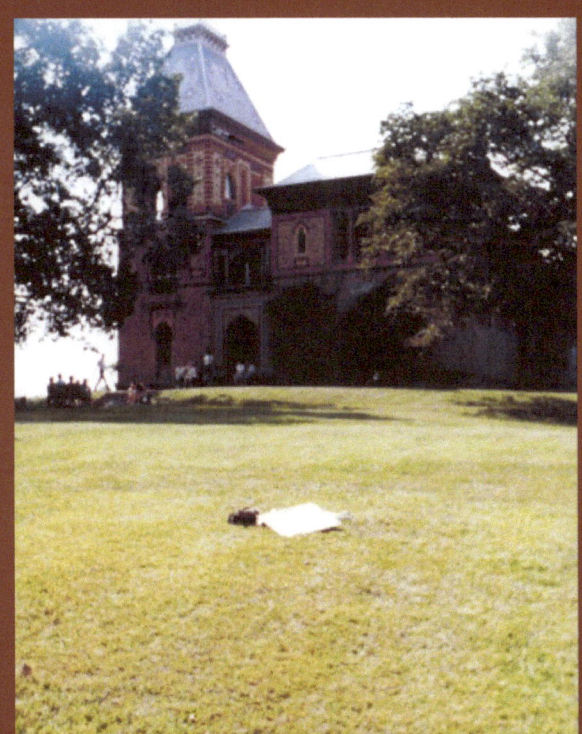

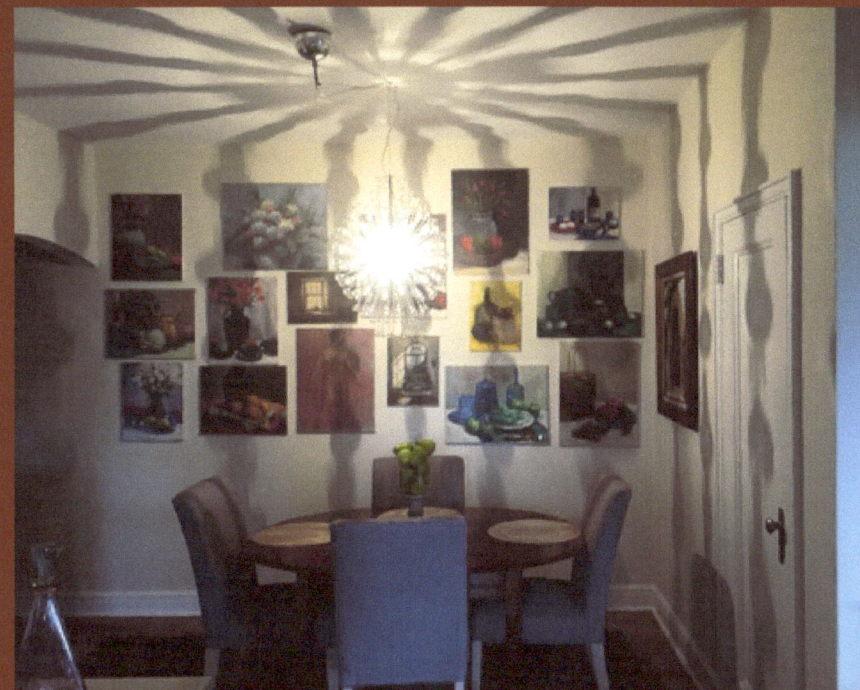

An curious picture at the Frederick Church mansion where she stepped away from drawing on the lawn to photograph her sketchpad. England, and a collection of Dorothy's paintings in a friend's dining room.

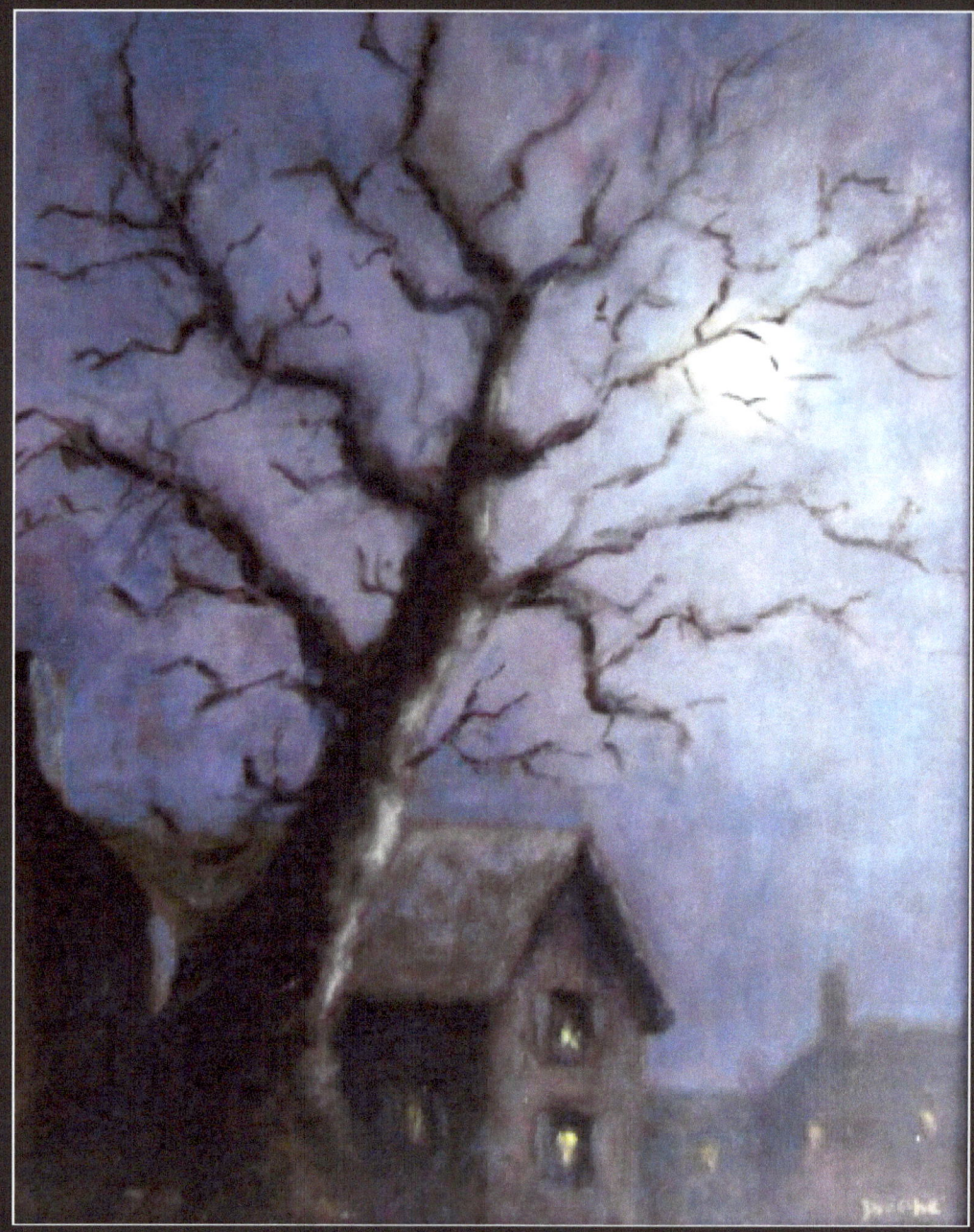

Night Before Winter

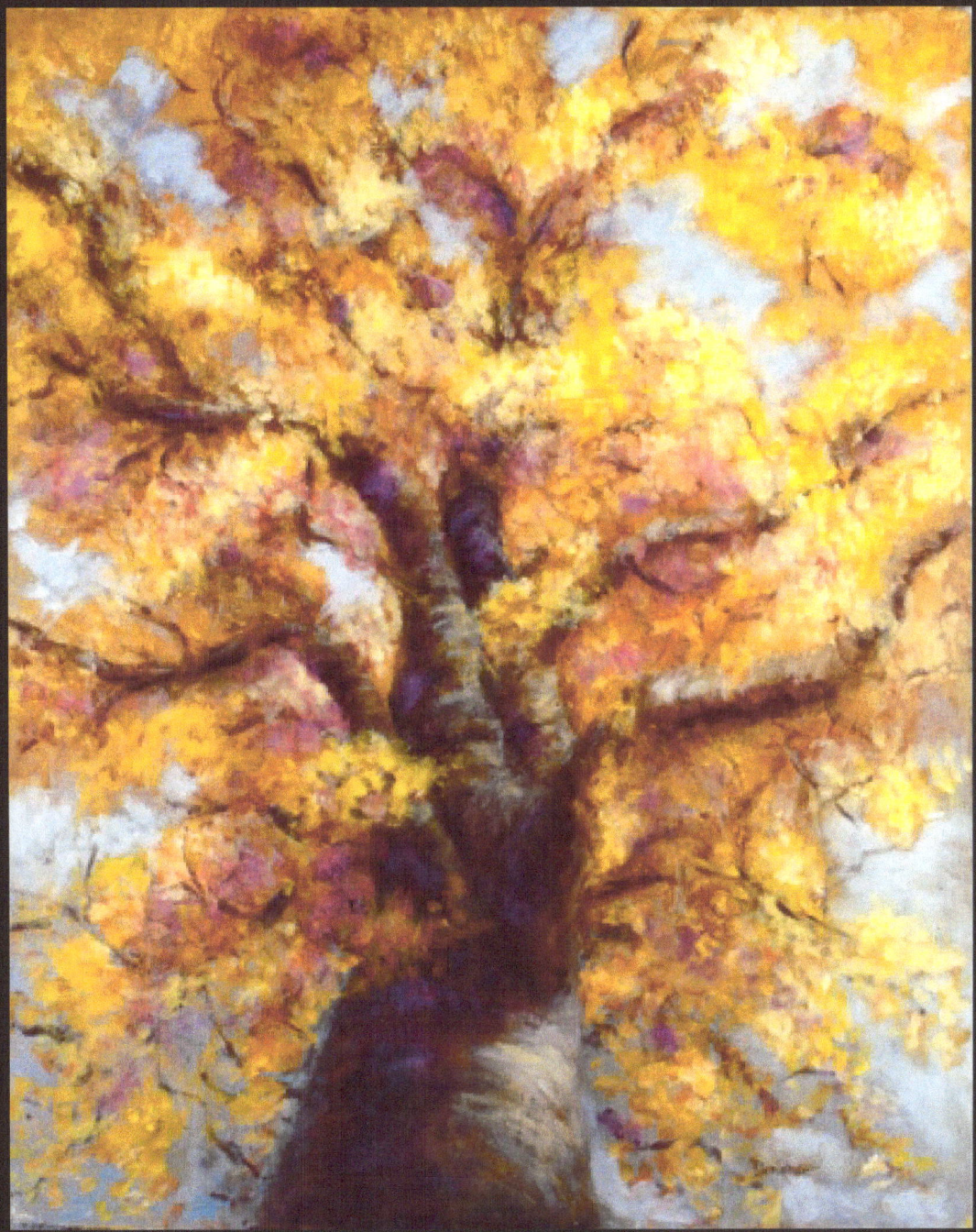

Gold Glory

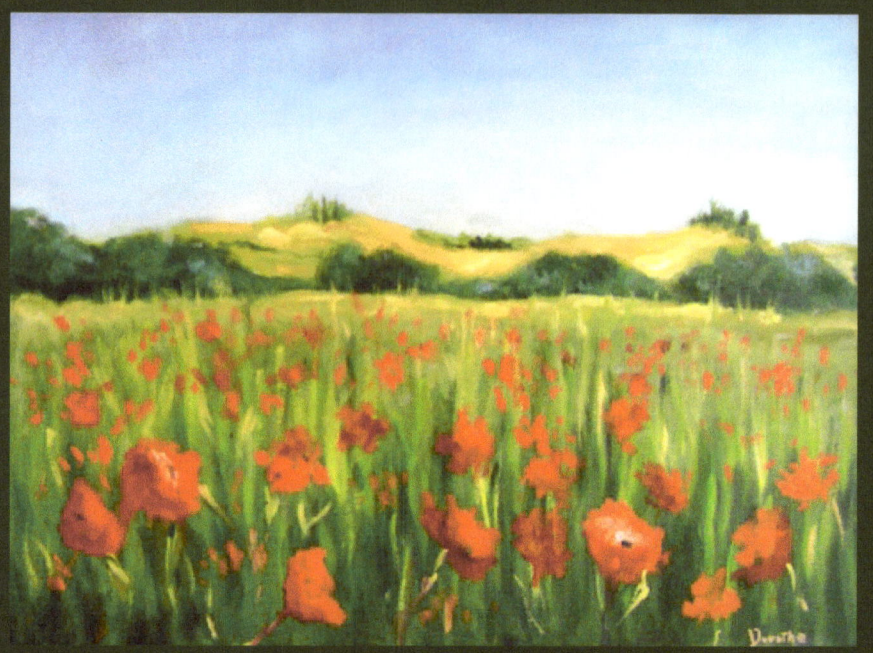
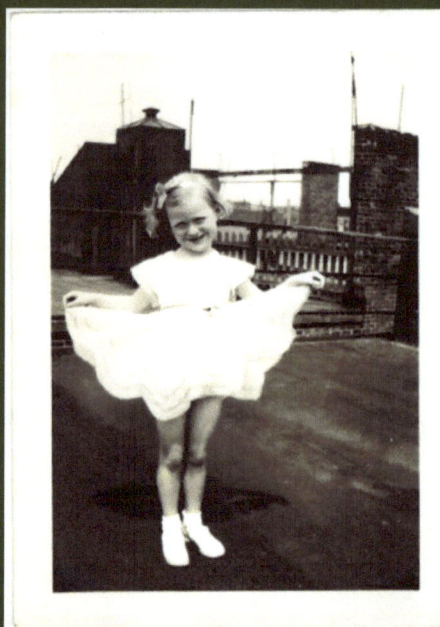

Poppy Field and Dorothy on a roof in Hoboken

www.ingramcontent.com/pod-product-compliance
Lightning Source LLC
Chambersburg PA
CBHW051102180526

45172CB00002B/743